Covered Bridges
OF NEW ENGLAND

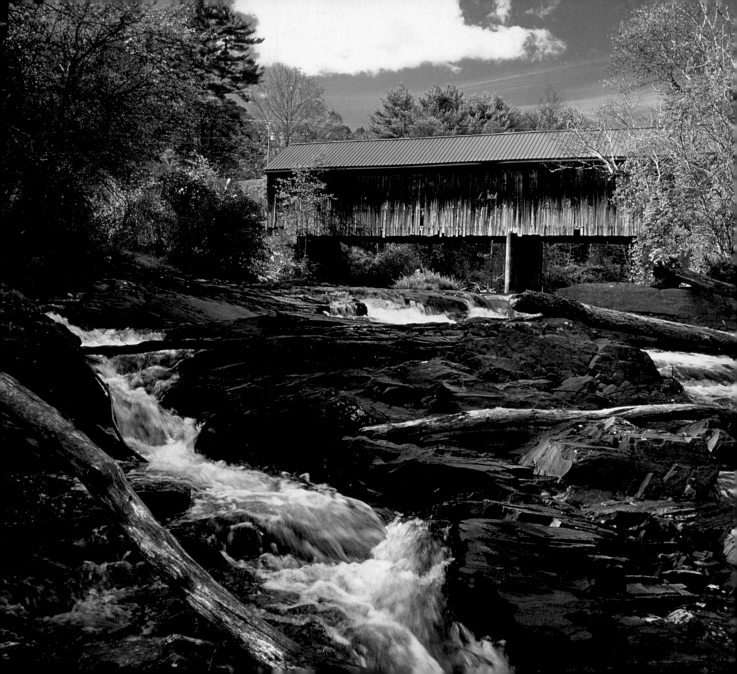

Covered Bridges
OF NEW ENGLAND

Jeffrey E. Blackman

THE COUNTRYMAN PRESS
WOODSTOCK, VERMONT

ACKNOWLEDGMENTS

My sincere thanks go out to:
L & I Photo Labs, New York City
Fuji Film, Valhalla, New York
New England's state maps

We welcome your comments and suggestions.
Please contact Editor, The Countryman Press,
P.O. Box 748, Woodstock, VT 05091,
or e-mail countrymanpress@wwnorton.com.

Text and photos copyright © 2008
by Jeffrey E. Blackman

First Edition

ISBN 978-0-88150-799-7

Book design and composition
by Eugenie S. Delaney

Published by The Countryman Press,
P.O. Box 748, Woodstock, Vermont 05091

Distributed by W. W. Norton & Company, Inc.,
500 Fifth Avenue, New York, NY 10110

Manufactured in China

10 9 8 7 6 5 4 3 2 1

FRONT COVER AND OVERLEAF
SAYERS BRIDGE
Thetford Center, Vermont

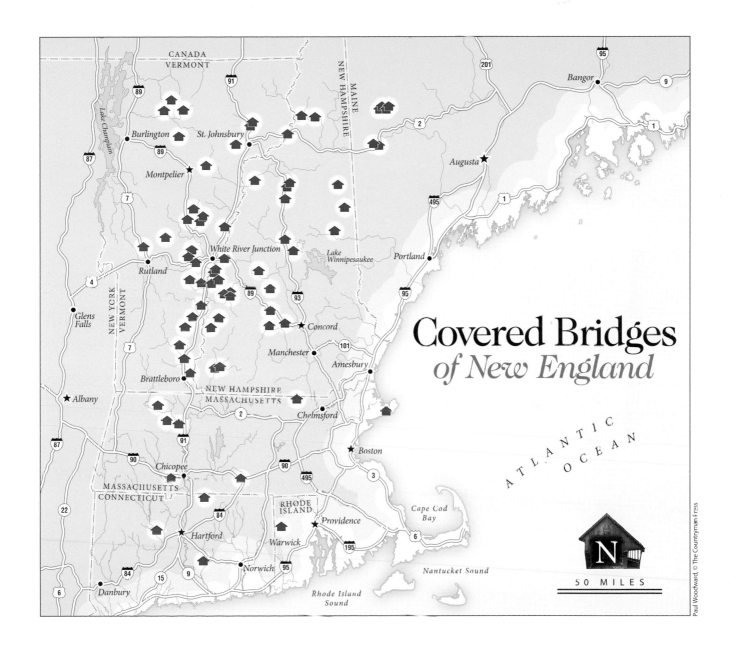

Covered Bridges
of New England

CANADA
VERMONT

NEW HAMPSHIRE
MAINE

Lake Champlain

Burlington
St. Johnsbury

Montpelier

Augusta

Bangor

Lake Winnipesaukee

Portland

Rutland

White River Junction

NEW YORK
VERMONT

Glens Falls

Concord

Manchester

Amesbury

Albany

Brattleboro

NEW HAMPSHIRE
MASSACHUSETTS

Chelmsford

Boston

ATLANTIC OCEAN

Chicopee

MASSACHUSETTS
CONNECTICUT

RHODE ISLAND

Cape Cod Bay

Hartford

Warwick

Providence

Nantucket Sound

Norwich

Danbury

Rhode Island Sound

N

50 MILES

Paul Woodward, © The Countryman Press

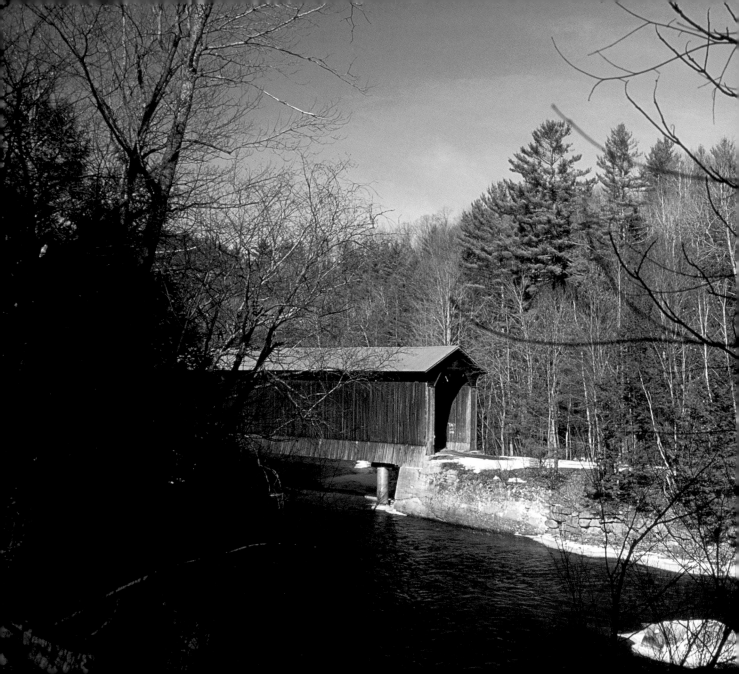

PREFACE

Photographing Covered Bridges

As a professional photographer for the past thirty-two years, my expertise has been in the sports world, both in the United States and abroad, and never having concentrated on any one sport continually at a time. Although the NFL, the PGA, and various forms of auto racing comprised a great portion of those years, I eventually got tired and bored.

Photographing covered bridges is my own personal project, which I find rewarding and challenging, particularly in some instances where I had to contend with the terrain to shoot a photo. Above all else, photographing the bridges is creative. In the sports arena, moments in time were captured (in most cases) within a give-and-take situation. Few images were obtained the way in which I photograph the bridges.

Once I locate each bridge I have the luxury of waiting for just the right light to illuminate it, and then after careful study from many vantage points, compose the photograph of each bridge in the most exciting and illuminating way possible, as many of the bridges resemble one another.

All of the bridges in this book were photographed:
- with film
- in natural light
- without filters
- without a tripod (all shots were taken with a hand-held camera)
- *without digital enhancements or alterations.*

Finally, these photographs were taken over a six-year period in all four seasons.

**PIER/CHANDLER STATION
RAILROAD BRIDGE**
Newport, New Hampshire.

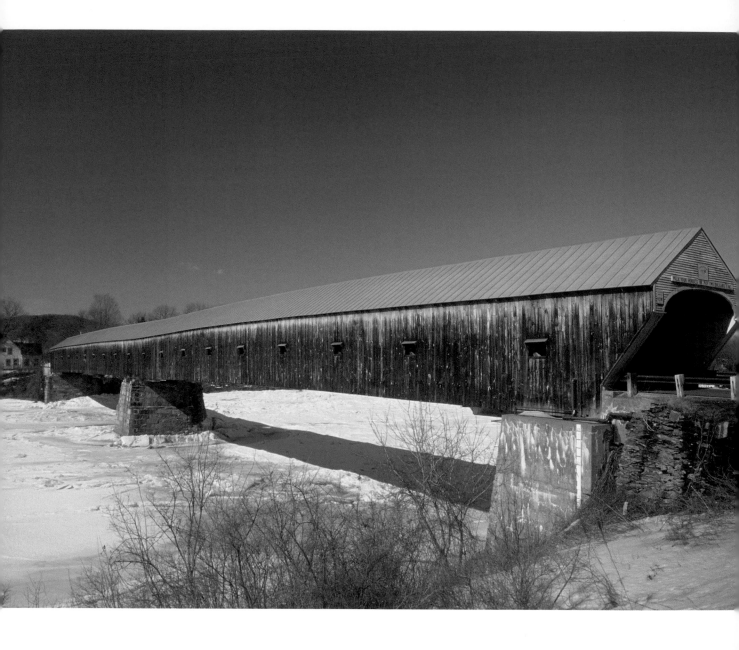

INTRODUCTION

Covered bridges are as vital today as when they first appeared on the American landscape. Unlike barns, which are disappearing because of age and the lack of upkeep, the covered bridge is a link from one landmass to another, separated by a body of water, whether it be a river, stream, or creek.

Unlike a barn, many covered bridges are an integral, functioning part of New England's infrastructure and need to survive for the purpose of remaining in use as they have been throughout the centuries. Many bridges are therefore currently under repair, while some are completely rebuilt.

The bridges in this book are artifacts of a simpler way of life, each with their own unique style and character. To travel the countryside and drive over and through them is a unique experience in itself—whether your trip is just to the store to buy a container of milk or a vacation in New England. Your peaceful excursion at times might be disrupted by the rattling of the wooden timbers as you pass through, but that's all part of the pleasant experience of using the bridge as it's been used throughout the years.

Some of the bridges are found among beautiful, scenic vistas, some in very remote areas, while others are right off major roads. Most are single-lane bridges while some are double barrel (two-lane) bridges. Some bridges have a pedestrian walkway alongside the bridge. At times courtesy prevails before traveling through a bridge, when another vehicle appears, at the same time. Please yield to oncoming traffic.

Enjoy your travels. Perhaps I'll see you along the way.

CORNISH-WINDSOR BRIDGE (1866)
Cornish, New Hampshire.
This is the longest two-span covered bridge in the world.

9

THE TRUSS

Throughout the United States there are twenty different truss designs. Only twelve can be found in New England. A truss is the framework that supports the covered bridge and its roof. It consists of rafters, posts, beams, and struts.

The truss is made of timbers and metal rods. Originally only timbers were used to cross a waterway, but over time these timbers deteriorated after exposure to the elements, and so they were covered to prevent the bridges' structure from breaking down.

The covered bridge was built to go over a body of water (in most cases) so that people could cross it by horse or by wagon—and today by motor vehicle.

Some truss designs are more elaborate than others, depending on the width or length of the bridge.

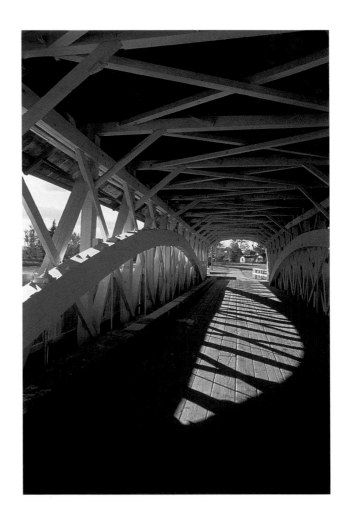

GROVETON BRIDGE
Groveton,
New Hampshire.
Example of a Burr truss.

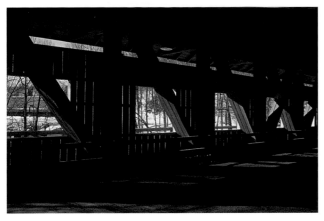

**CHESTER H. WATEROUS
NEHEMIAH JEWETT'S BRIDGE**
East Pepperell, Massachusetts.
Example of a Pratt truss.

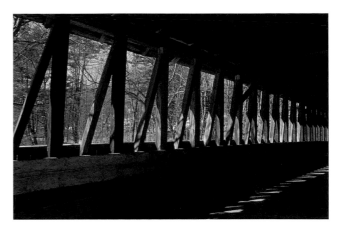

**BLACKSMITH SHOP
KENYON HILL BRIDGE #22**
Cornish, New Hampshire.
Example of a multiple kingpost truss.

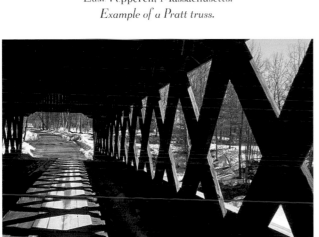

KENISTON BRIDGE
Andover, New Hampshire.
Example of a Howe truss.

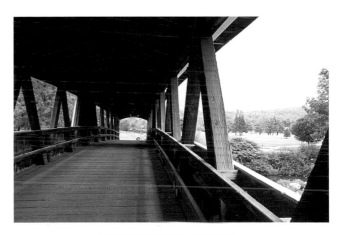

WENTWORTH BRIDGE
Jackson, New Hampshire.
Example of a Warren truss.

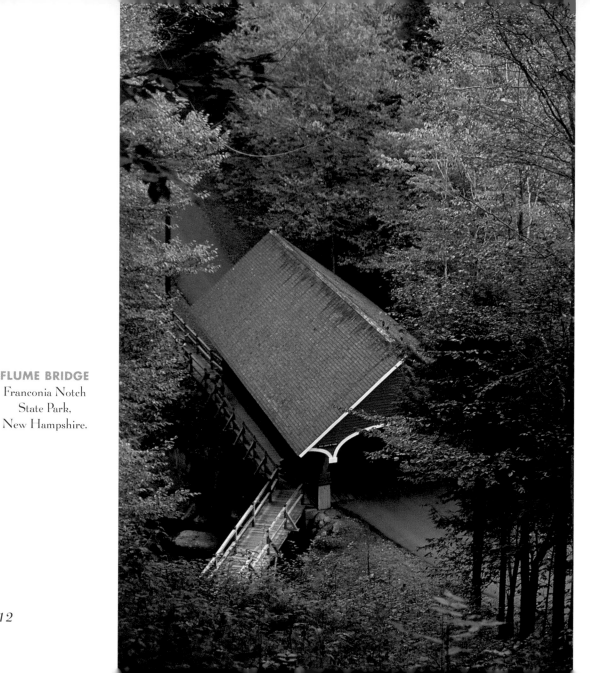

FLUME BRIDGE
Franconia Notch
State Park,
New Hampshire.

12

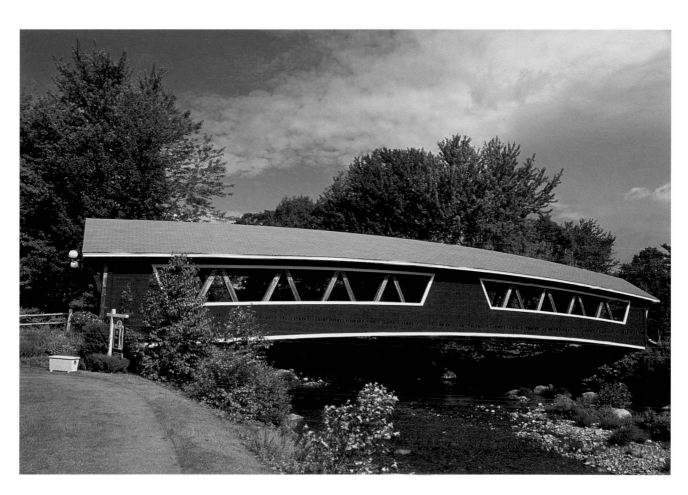

**WENTWORTH
GOLF CLUB BRIDGE**
Jackson, New Hampshire.

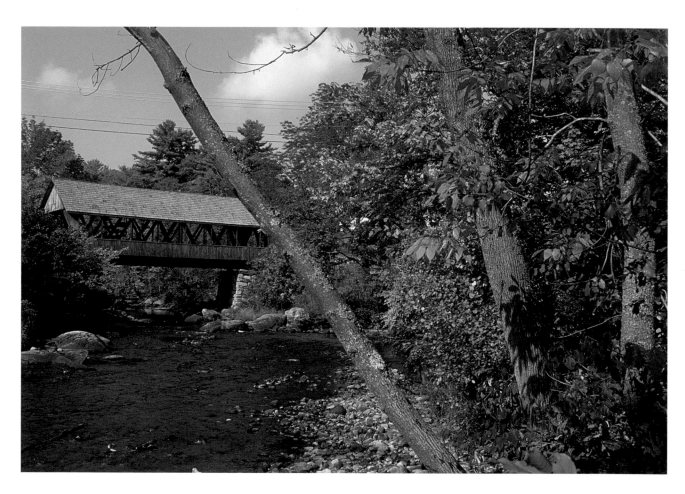

PACKARD HILL BRIDGE
Lebanon, New Hampshire.
This is the very first bridge
I photographed, six years ago.

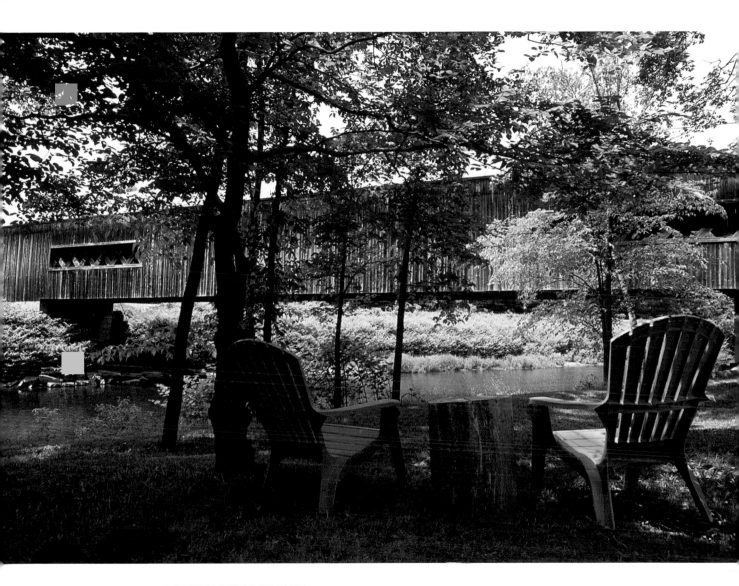

BARTONSVILLE BRIDGE
Bartonsville, Vermont.

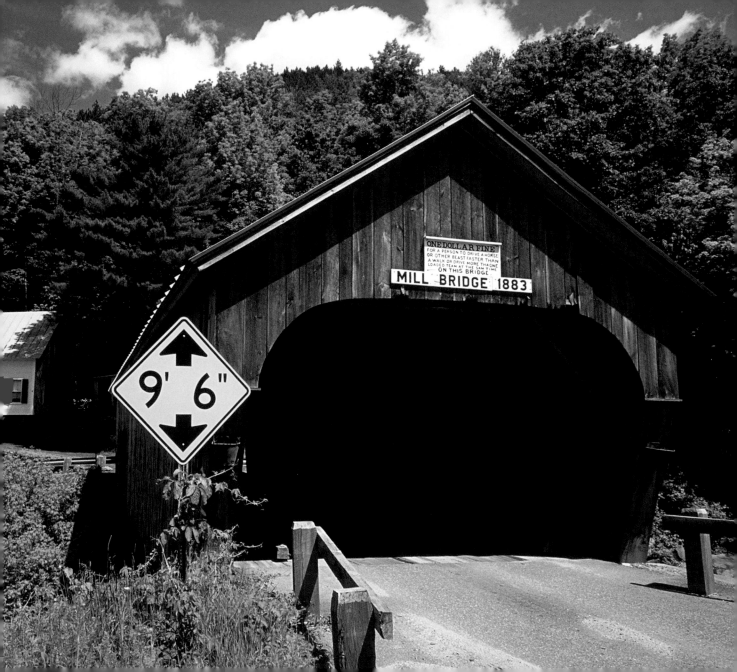

ONE DOLLAR FINE
FOR A PERSON TO DRIVE A HORSE
OR OTHER BEAST FASTER THAN
A WALK OR DRIVE MORE THAN ONE
LOADED TEAM AT THE SAME TIME
ON THIS BRIDGE

MILL BRIDGE 1883

9' 6"

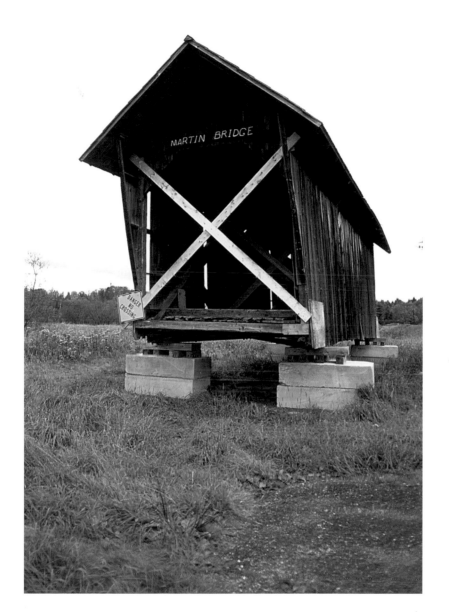

OPPOSITE
THE MILL BRIDGE
Tunbridge, Vermont.

LEFT
MARTIN BRIDGE
Plainfield, Vermont.

17

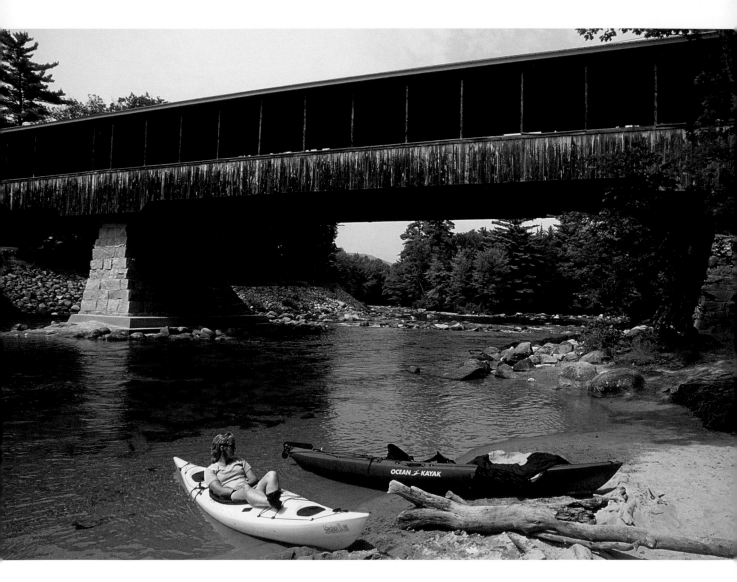

SACO RIVER BRIDGE
Conway, New Hampshire.

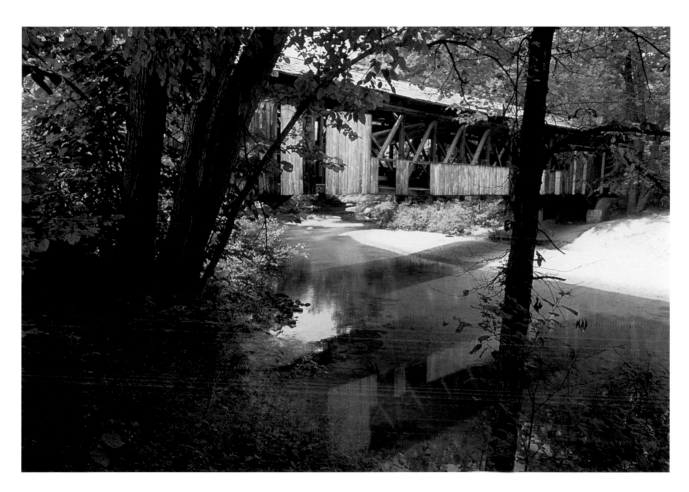

WHITTIER BEAR CAMP
West Ossipee, New Hampshire.

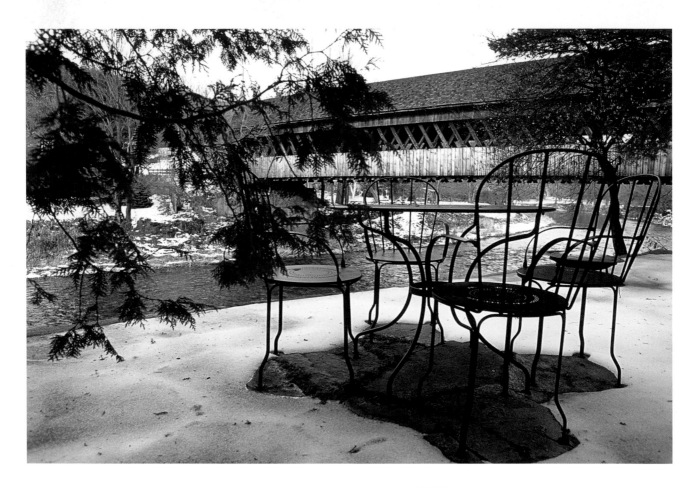

ABOVE
MIDDLE BRIDGE
Woodstock, Vermont.

—

OPPOSITE
TEAGO/SOUTH POMFRET SMITH BRIDGE
South Pomfret, Vermont.
Example of a town truss.

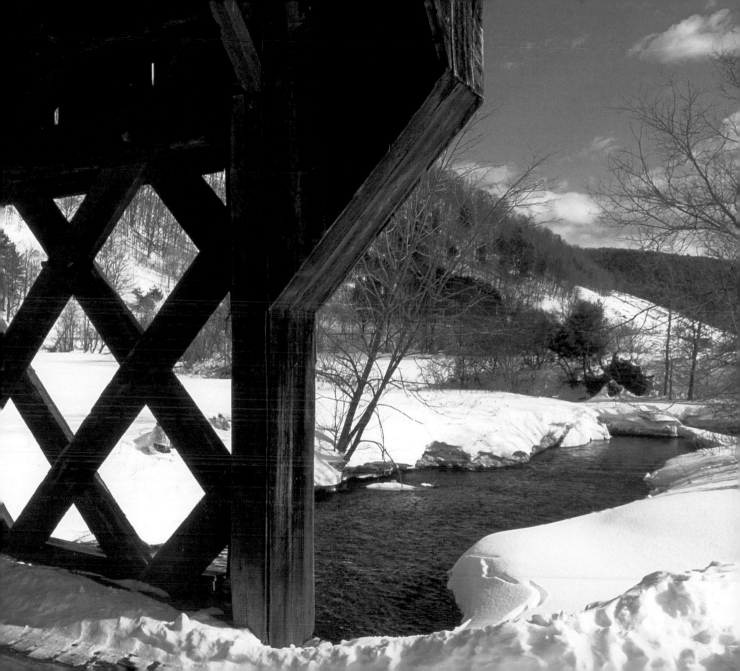

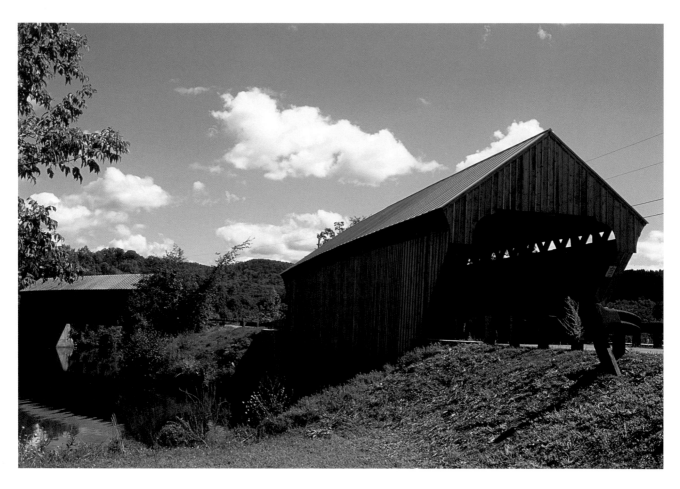

**WILLARD/WILLARD'S
(EAST TWIN) BRIDGE**
North Hartland, Vermont.

**WILLARD/WILLARD'S
(WEST TWIN) BRIDGE**

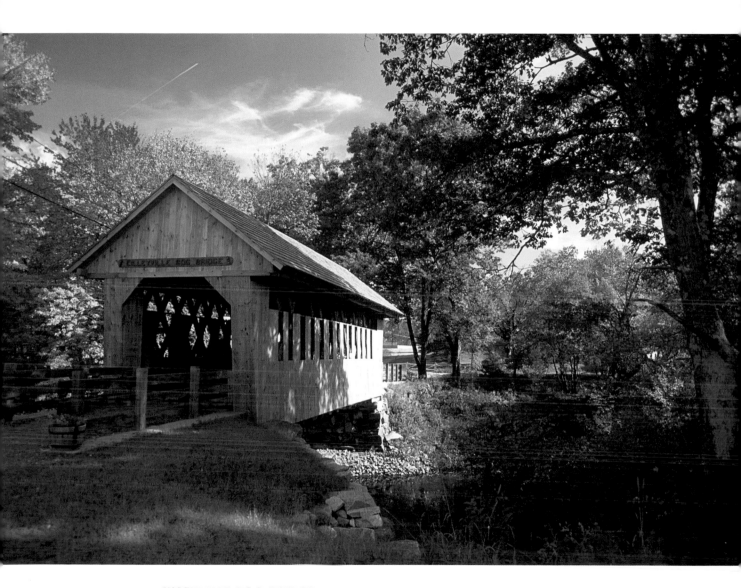

CILLEYVILLE BOG BRIDGE
Andover, New Hampshire.

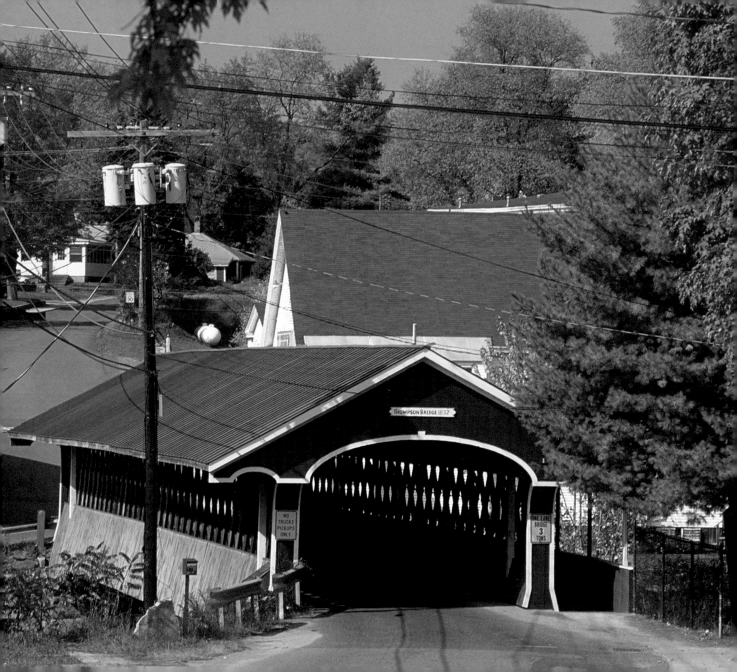

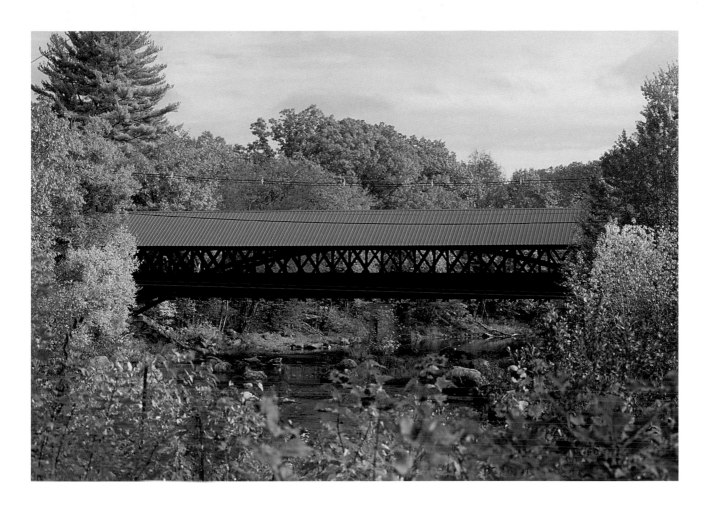

ABOVE
ROWELL BRIDGE
Hopkinton, New Hampshire.

OPPOSITE
THOMPSON BRIDGE
West Swanzey, New Hampshire.

**WRIGHT'S
BRIDGE**
Newport,
New Hampshire.

26

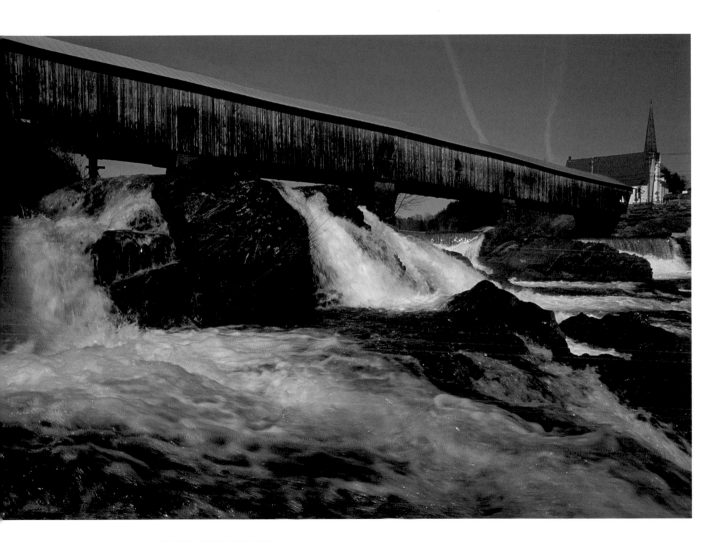

BATH BRIDGE #28
Bath, New Hampshire.

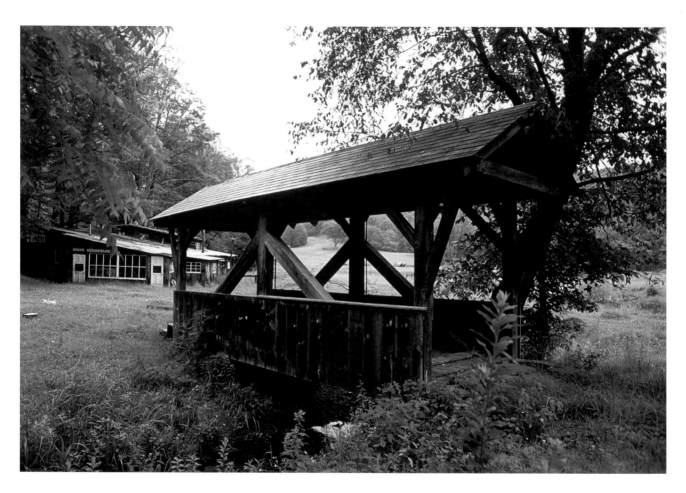

GRAY'S SUGARHOUSE BRIDGE
Ashfield, Massachusetts.

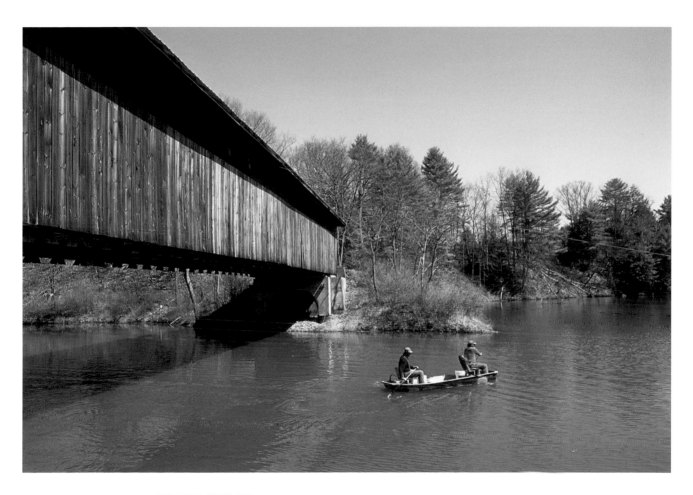

ENGELL BRIDGE
Orford, New Hampshire.

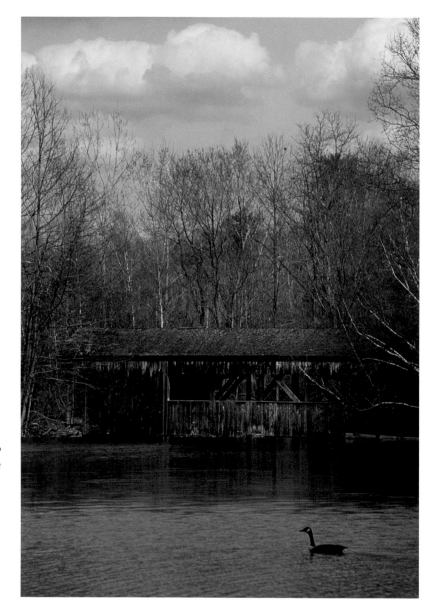

DUMMERSTON BRIDGE
Old Sturbridge
Village,
Sturbridge,
Massachusetts.
This bridge was relocated to
Old Sturbridge Village from
Dummerston,
Vermont.

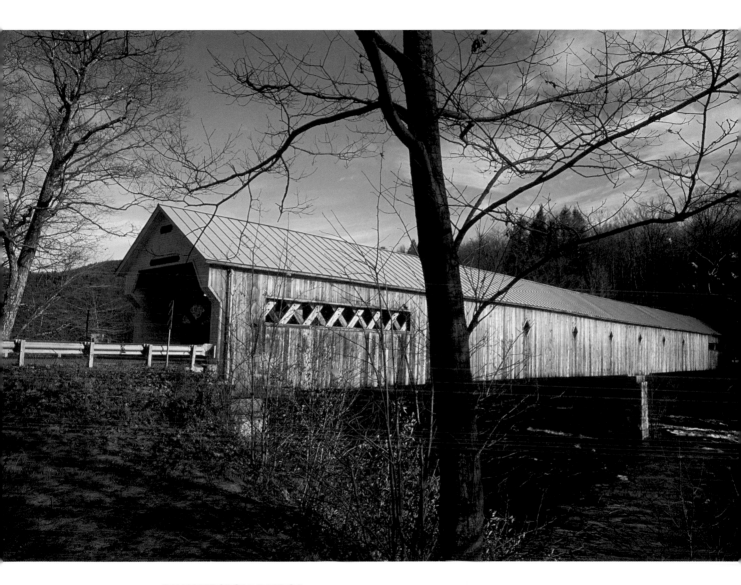

DUMMERSTON BRIDGE
West Dummerston, Vermont.

LOVELY BRIDGE
Pittsfield, Vermont.

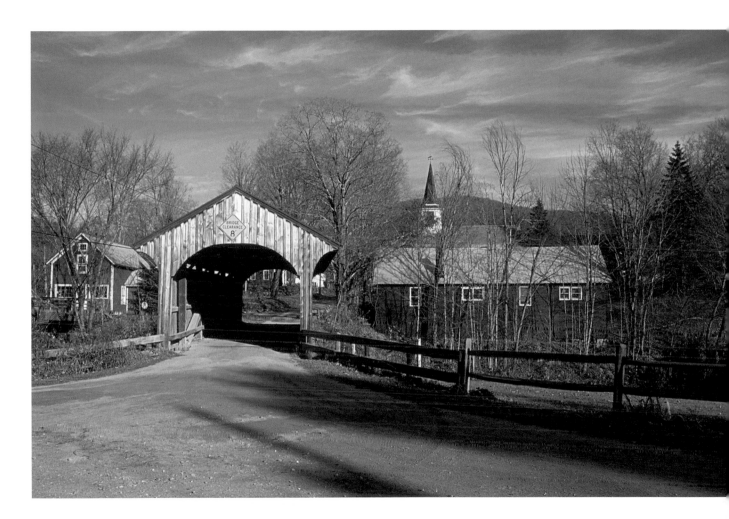

CHURCH STREET/VILLAGE MEAT MARKET/LOWER BRIDGE

Waterville, Vermont.

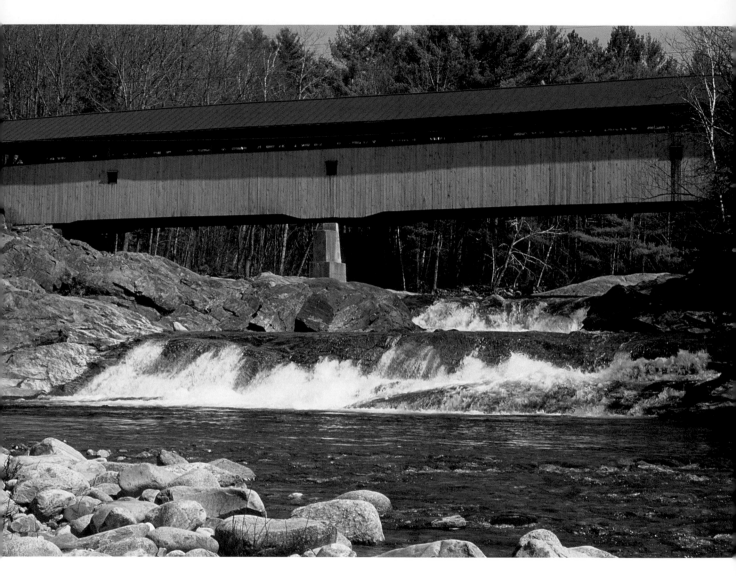

SWIFTWATER BRIDGE
Bath, New Hampshire.

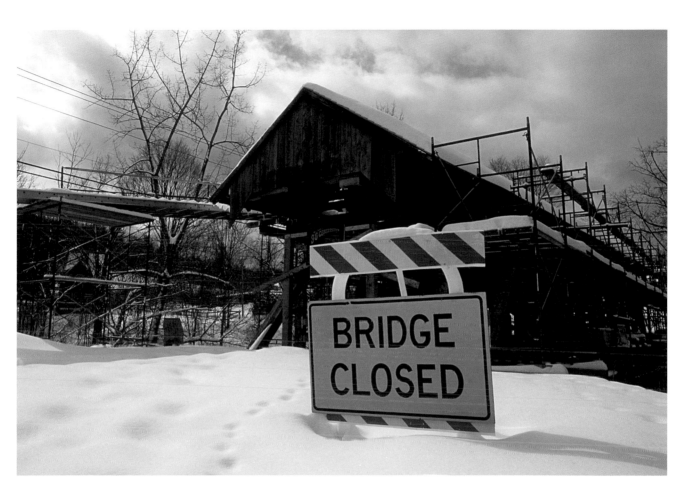

BURKEVILLE BRIDGE
Conway, Massachusetts.

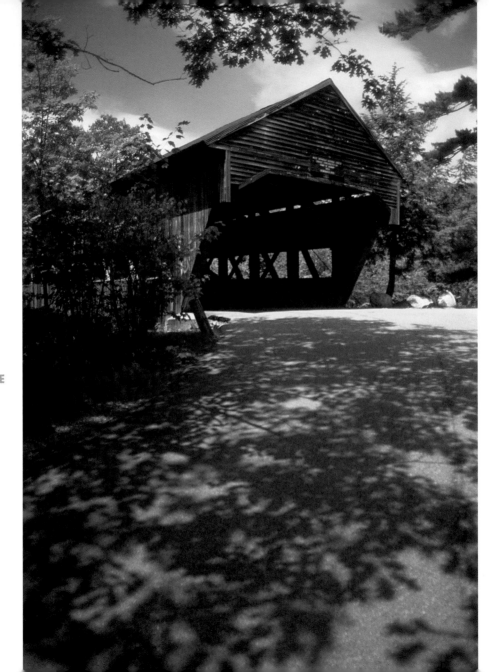

ALBANY BRIDGE
Conway,
New Hampshire.

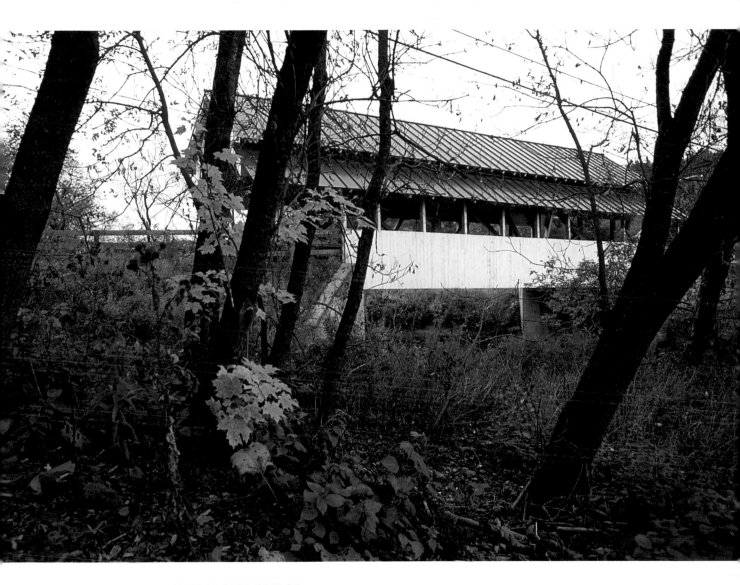

MILLER'S RUN BRIDGE
Lyndonville, Vermont.

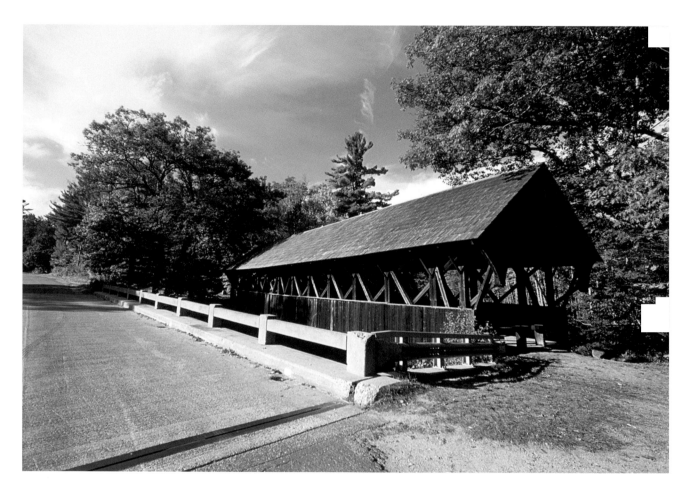

ARTIST'S BRIDGE
Bethel, Maine.

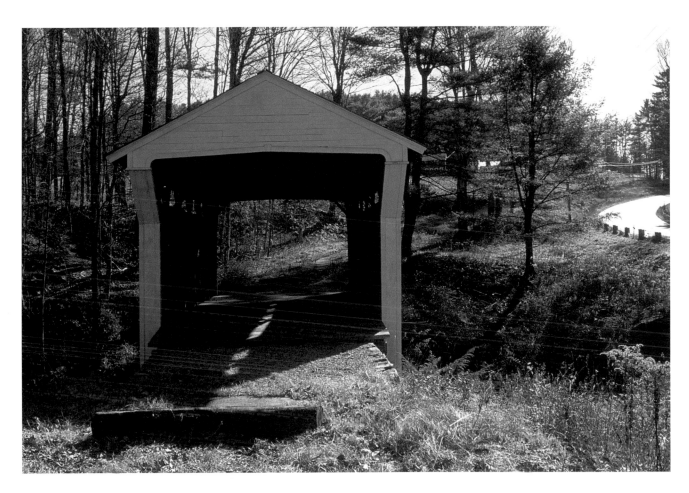

PRENTISS BRIDGE #19
Langdon, New Hampshire.

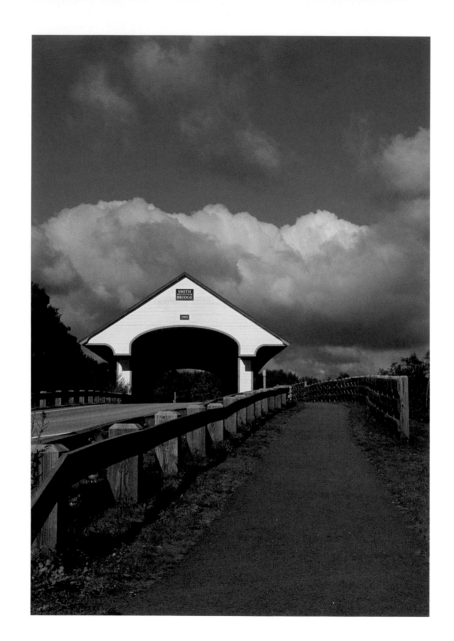

SMITH BRIDGE
Plymouth,
New Hampshire.

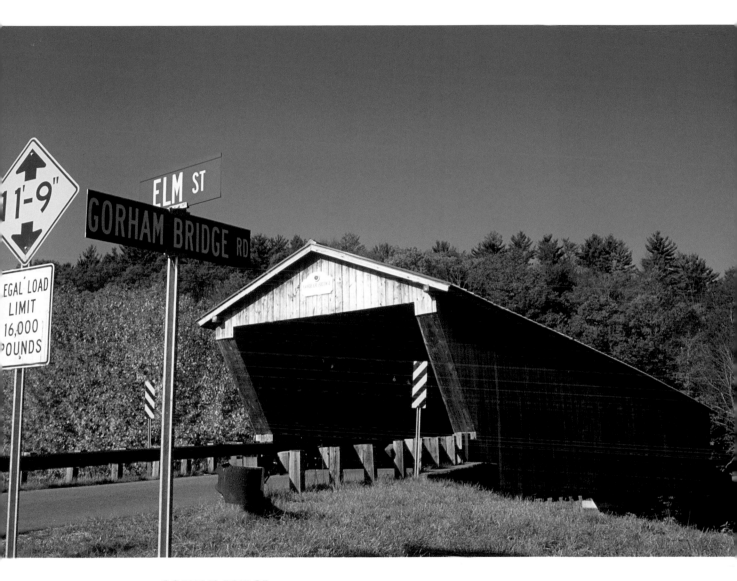

GORHAM BRIDGE

Pittsford, Vermont.

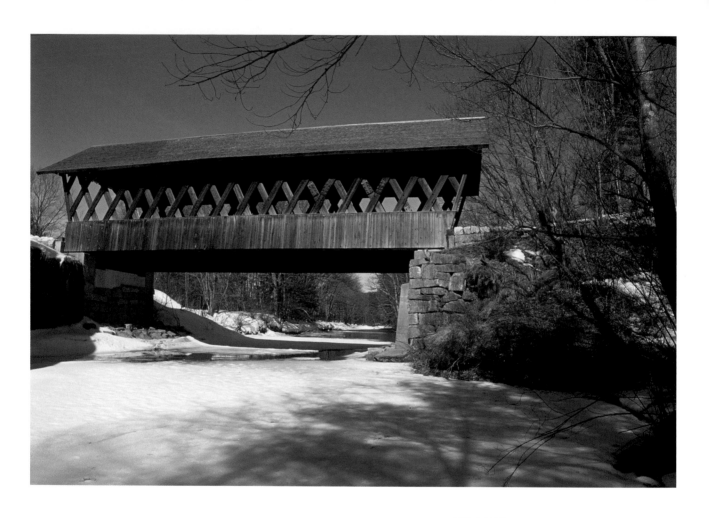

KENISTON BRIDGE
Andover, New Hampshire.

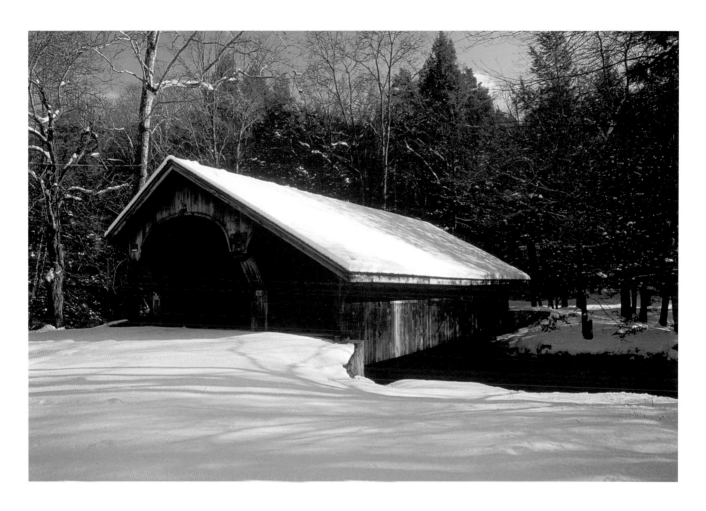

JOHNSVILLE VILLAGE BRIDGE
Johnsville, Connecticut.

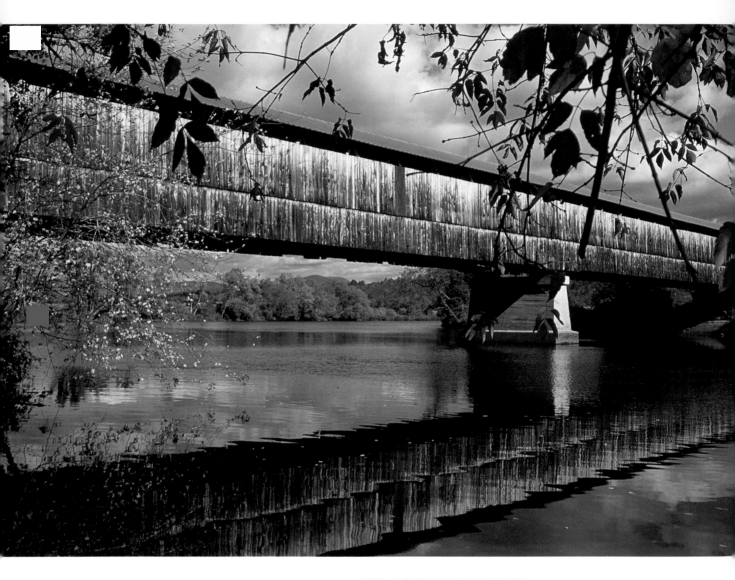

THE MOUNT ORNE BRIDGE
Lancaster, New Hampshire to Lunenburg, Vermont.

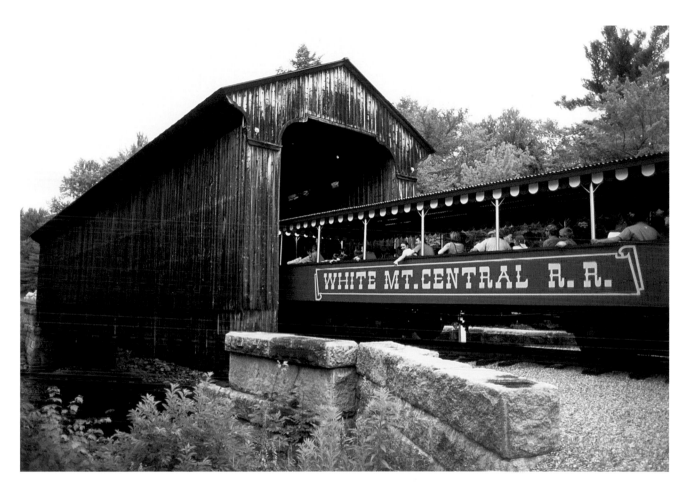

CLARK'S RAILROAD BRIDGE
North Woodstock, New Hampshire.

WRIGHT'S BRIDGE
Newport,
New Hampshire.

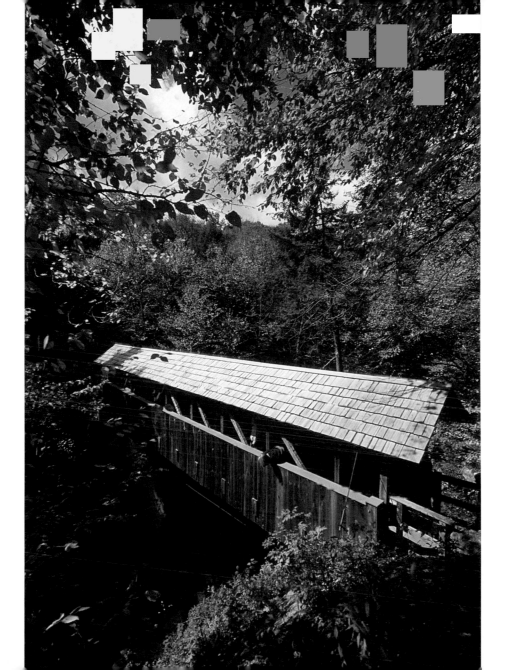

SENTINEL PINE BRIDGE
Franconia Notch
State Park,
New Hampshire.

47

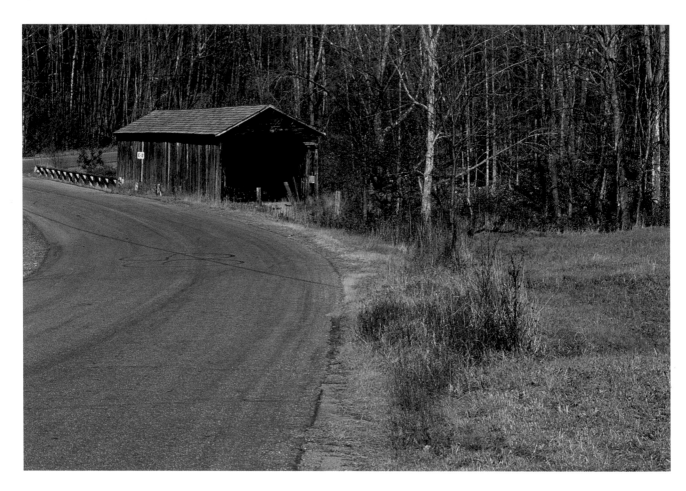

**MCDERMOTT/COLD RIVER
BRIDGE**
Langdon, New Hampshire.

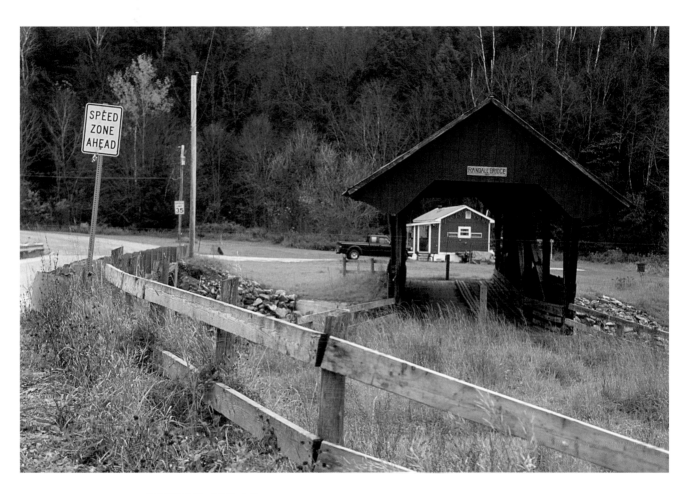

RANDALL BRIDGE
Lyndon Center, Vermont.

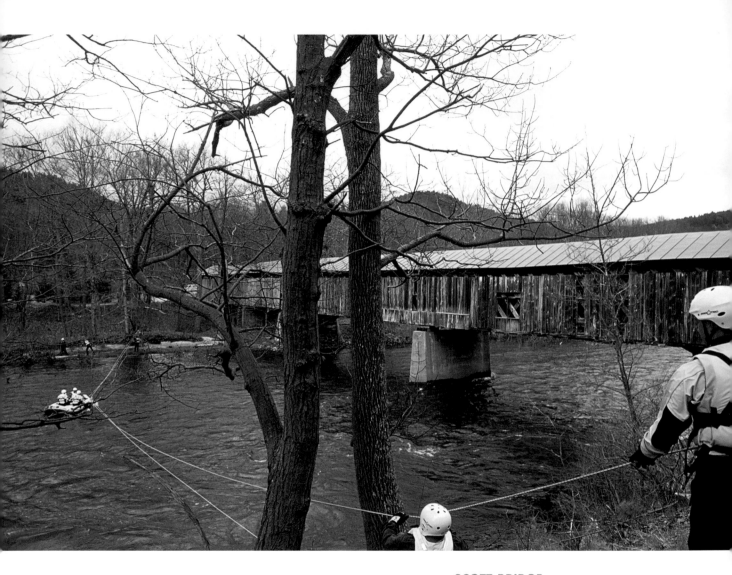

SCOTT BRIDGE
Townshend, Vermont.
Firemen practicing water rescue.

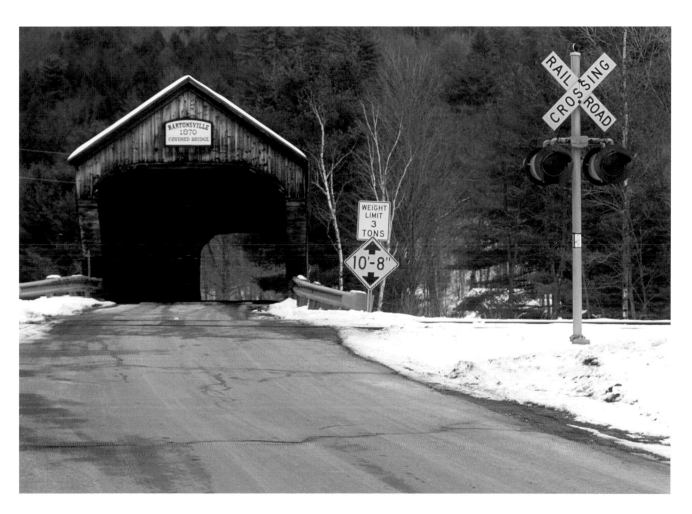

BARTONSVILLE BRIDGE
Bartonsville, Vermont.

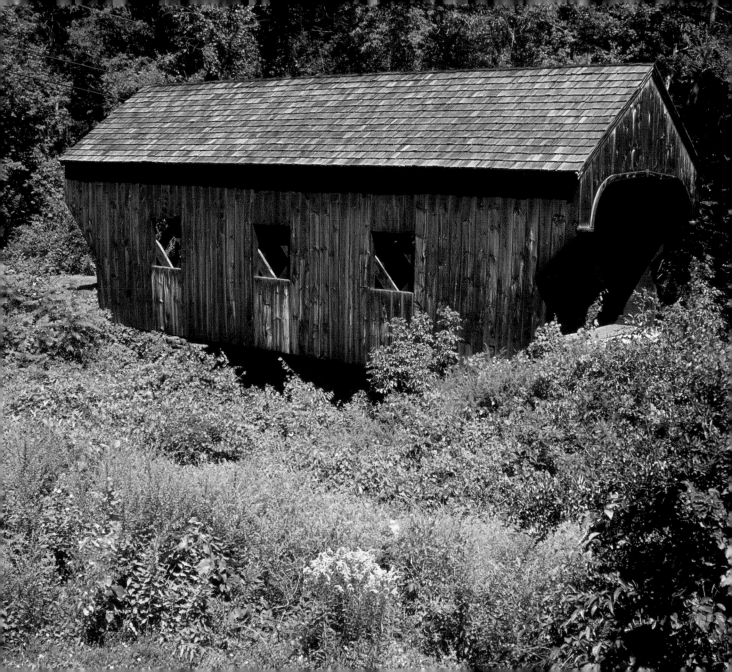

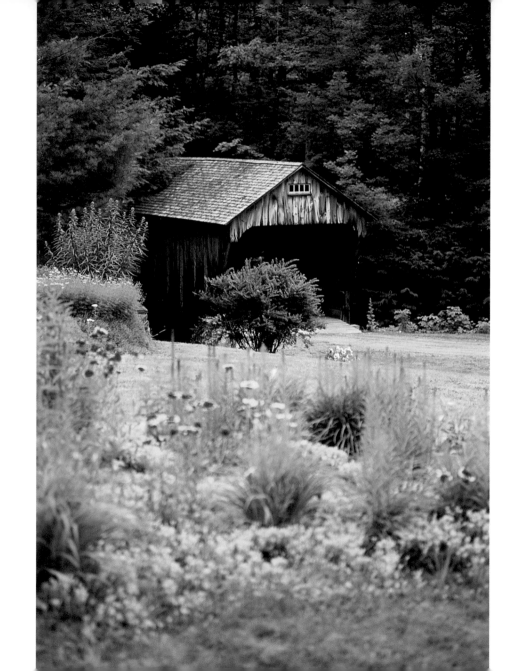

CREAMERY BRIDGE
Ashfield,
Massachusetts.

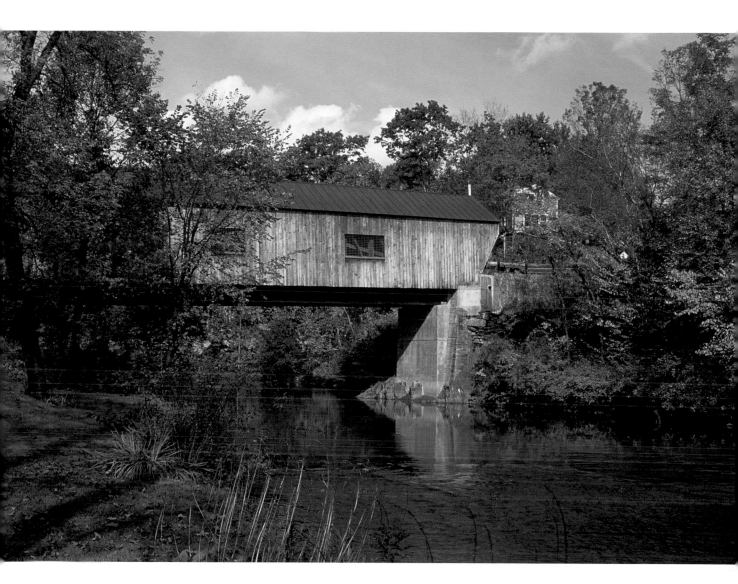

UNION VILLAGE BRIDGE
Thetford, Vermont.

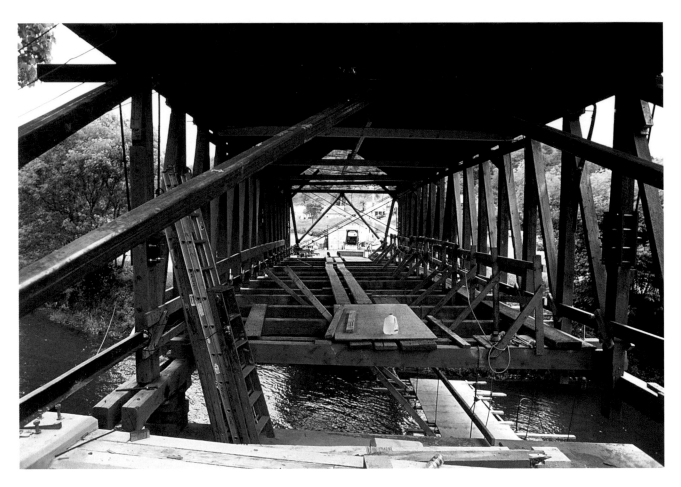

THE CILLEY (LOWER) BRIDGE
Tunbridge, Vermont.
Example of a multiple kingpost truss.

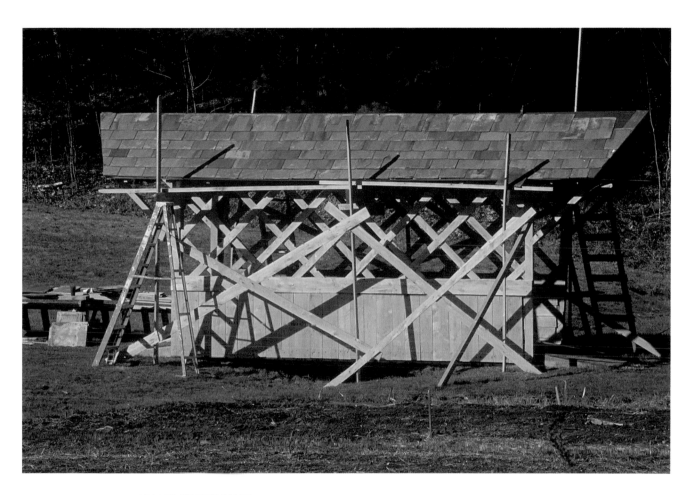

NAME UNKNOWN
Townshend, Vermont.
(See completed
bridge on page 96.)

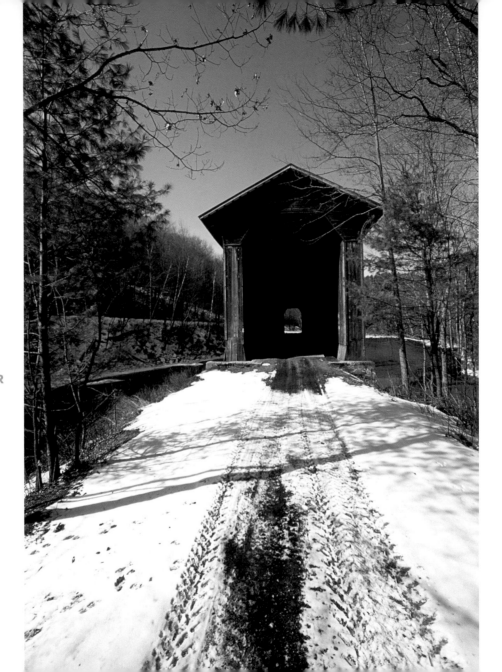

**PIER/CHANDLER
STATION
RAILROAD
BRIDGE**
Newport,
New Hampshire.

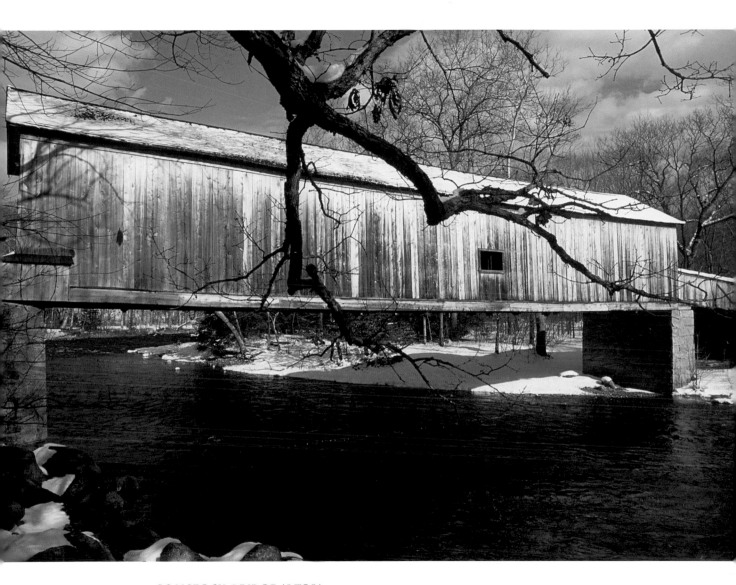

COMSTOCK BRIDGE (1791)
Westchester, Connecticut.

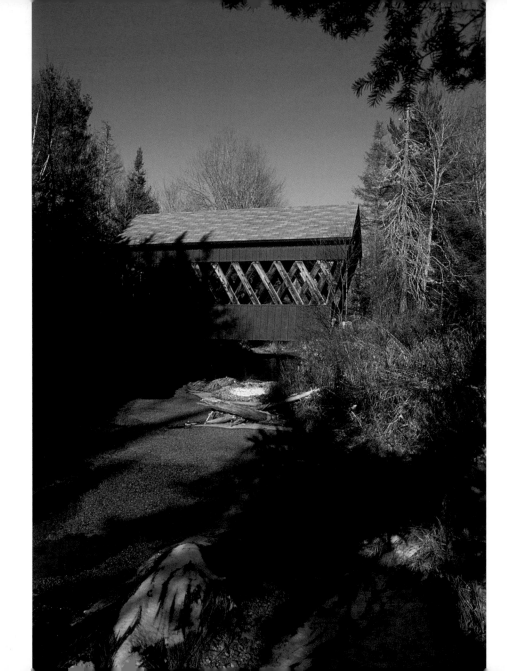

RIGHT
BRUNDAGE BRIDGE
East Grafton,
New Hampshire.

———

OPPOSITE
JACK-O'-LANTERN BRIDGE
Woodstock,
New Hampshire.

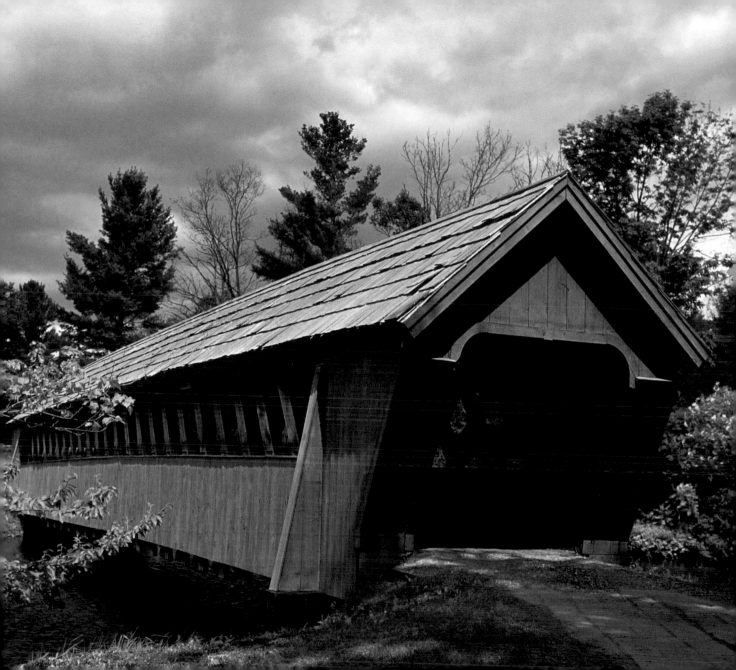

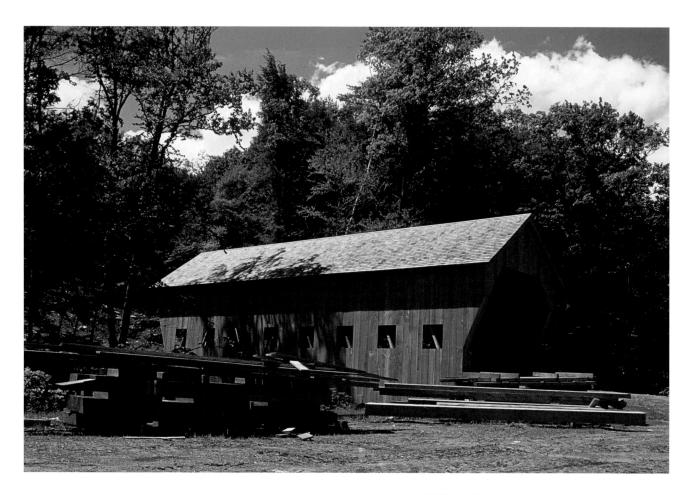

MILL BROOK BRIDGE
Reading, Vermont.

GOODRICH BRIDGE
Stanley Park,
Westfield,
Massachusetts.

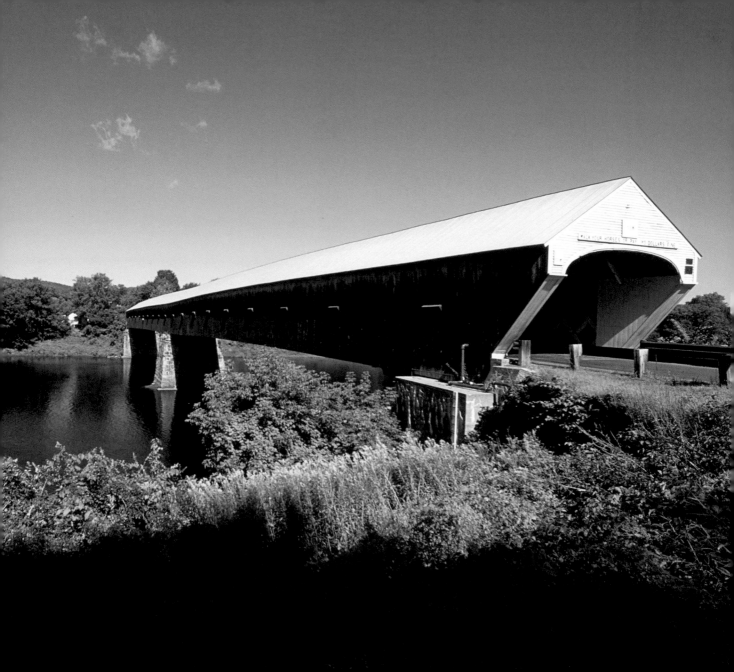

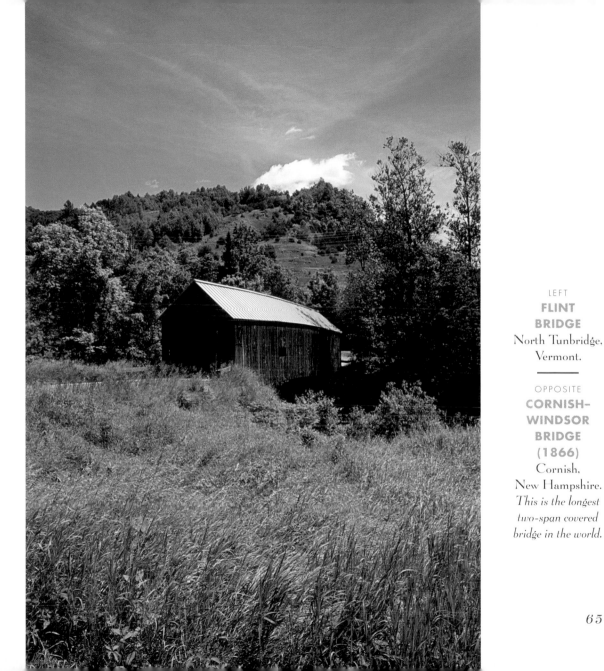

LEFT
FLINT
BRIDGE
North Tunbridge,
Vermont.

OPPOSITE
CORNISH–
WINDSOR
BRIDGE
(1866)
Cornish,
New Hampshire.
This is the longest
two-span covered
bridge in the world.

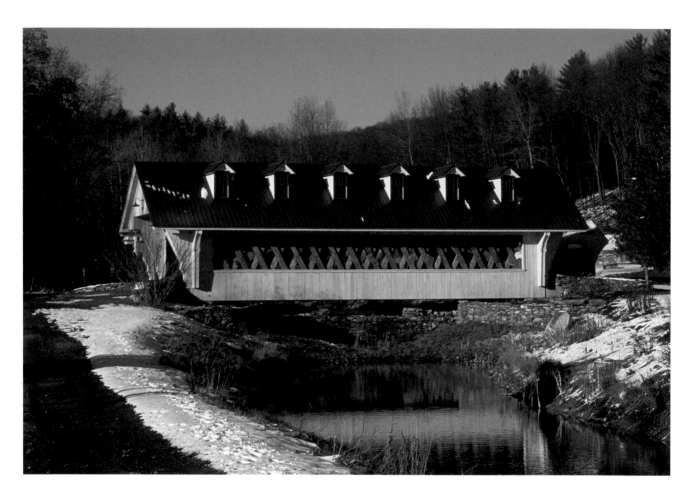

**WORTHINGTON POND
FARM BRIDGE**
Somers, Connecticut.

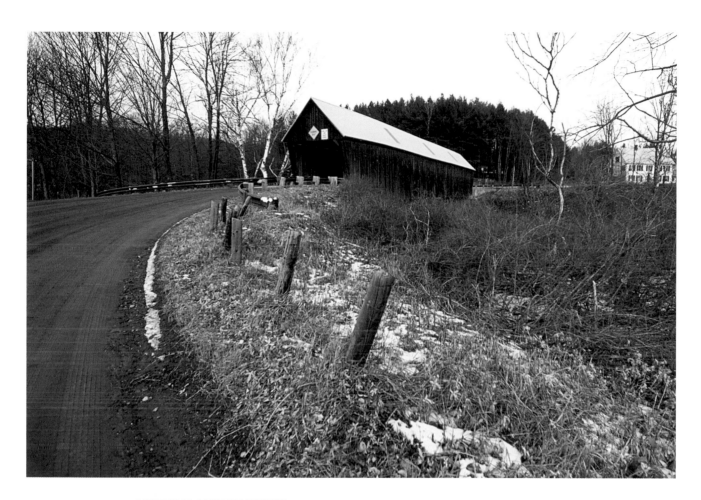

LINCOLN BRIDGE (1877)
over the
Ottauquechee River,
West Woodstock, Vermont.

BISSELL BRIDGE
Charlemont, Massachusetts.

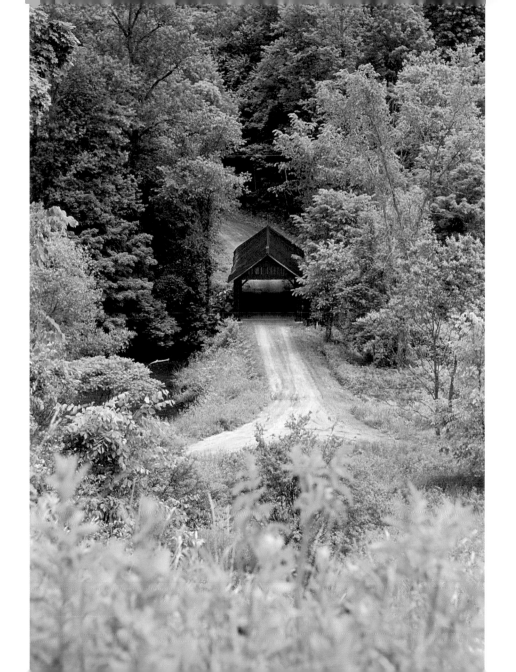

**UPPER
BLAISDELL
BRIDGE**
East Randolph,
Vermont.

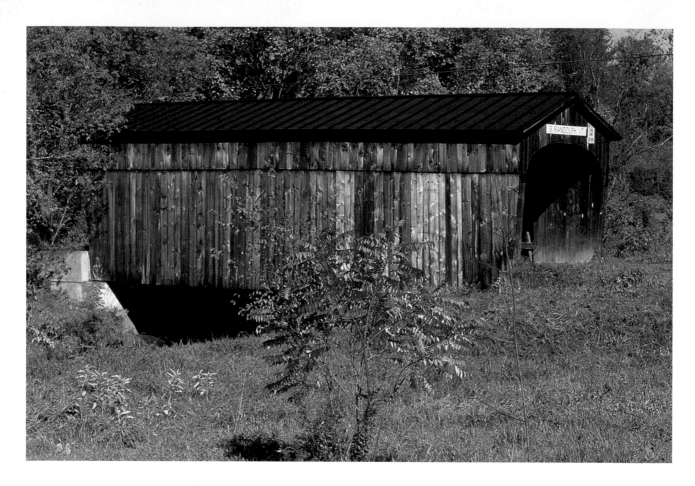

ABOVE
RANDOLPH BRIDGE
South Randolph, Vermont.

———

OPPOSITE
WATERLOO
COVERED BRIDGE #13
Warner, New Hampshire.

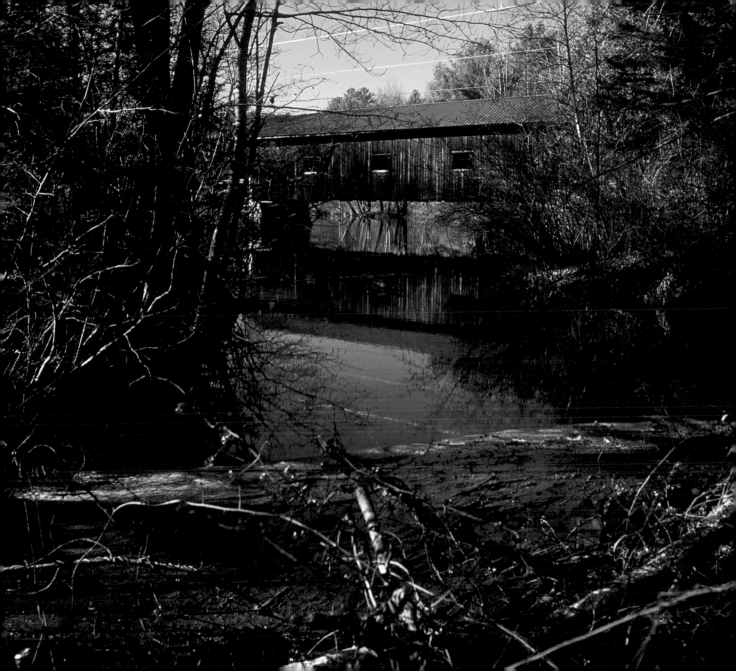

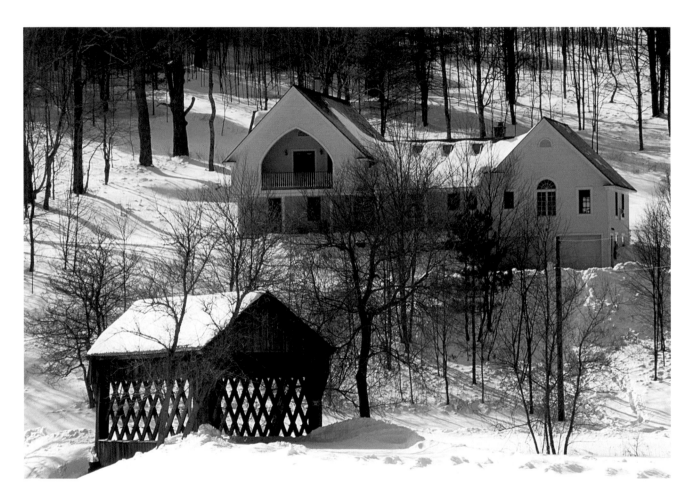

TEAGO/SOUTH POMFRET
SMITH BRIDGE
South Pomfret, Vermont.
Example of a town truss.

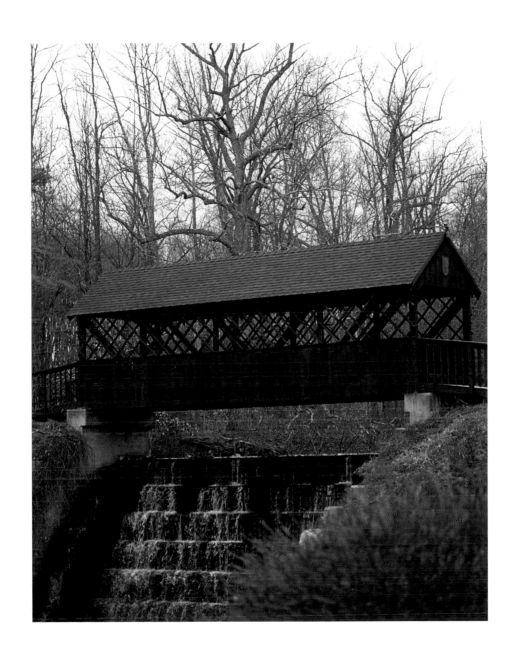

HUCKLEBERRY HILL BRIDGE
Unionville,
Connecticut.

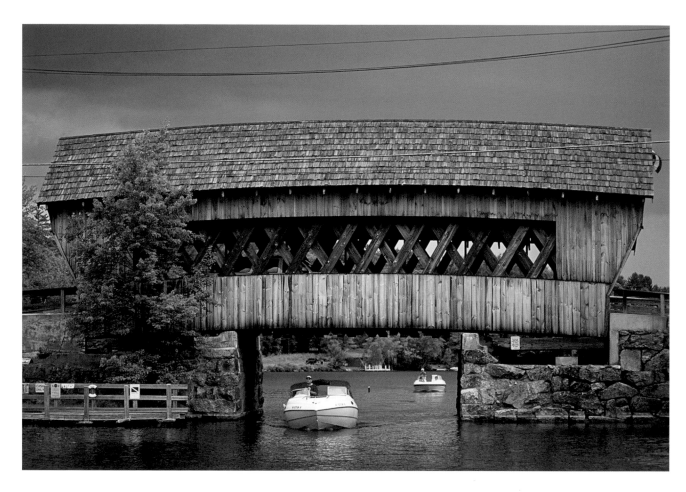

SQUAM RIVER BRIDGE
Ashland, New Hampshire.

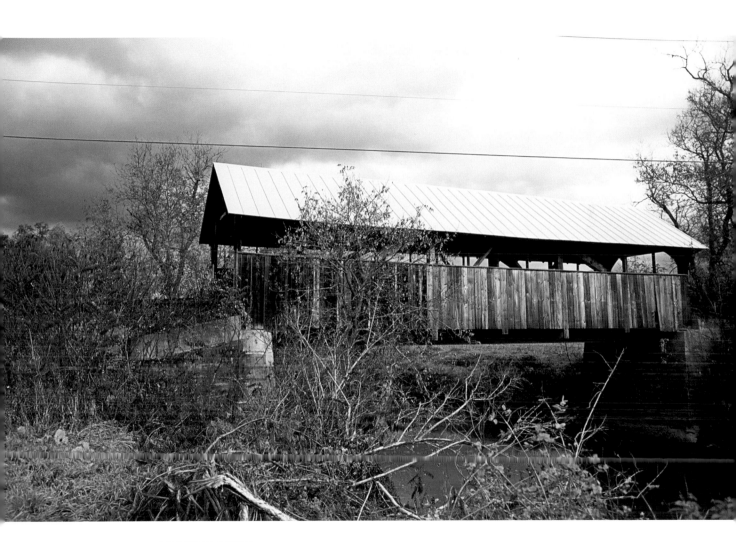

COBURN BRIDGE
Plainfield, Vermont.

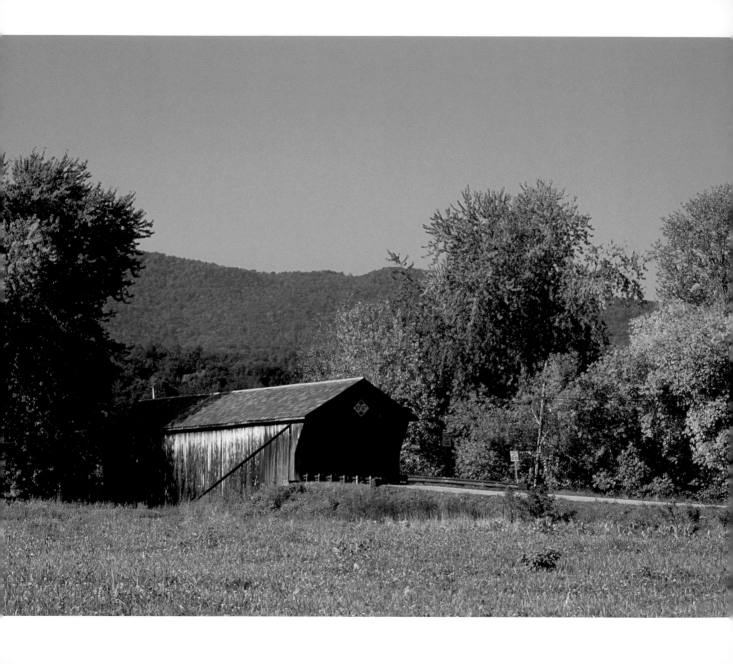

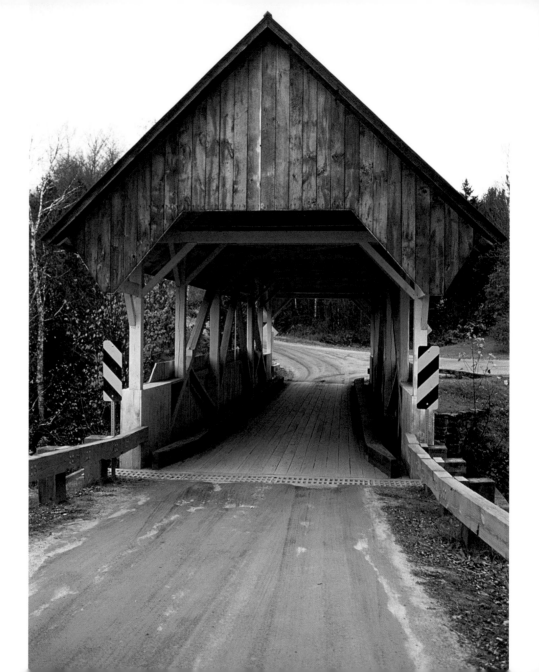

**GREENBANK
HOLLOW BRIDGE**
Danville, Vermont.

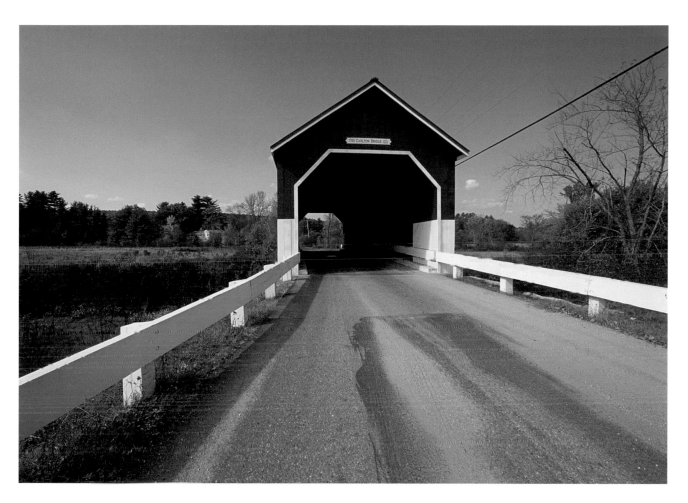

CARLTON BRIDGE
Swansey, New Hampshire.

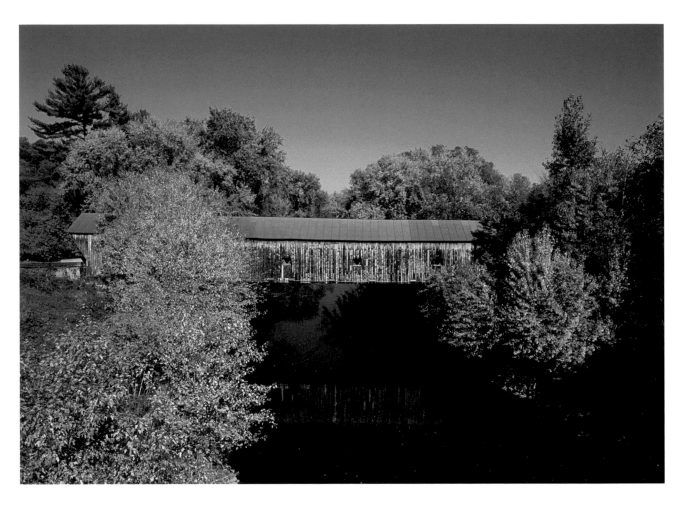

HAMMOND BRIDGE
Pittsford, Vermont.

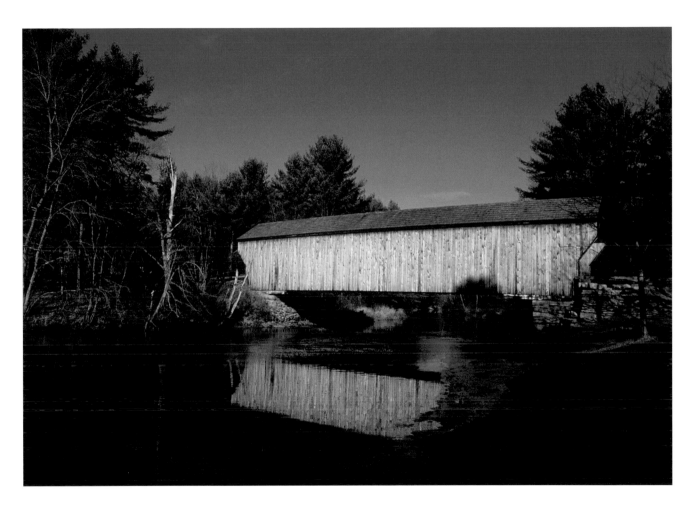

CORBIN BRIDGE
North Newport, New Hampshire.

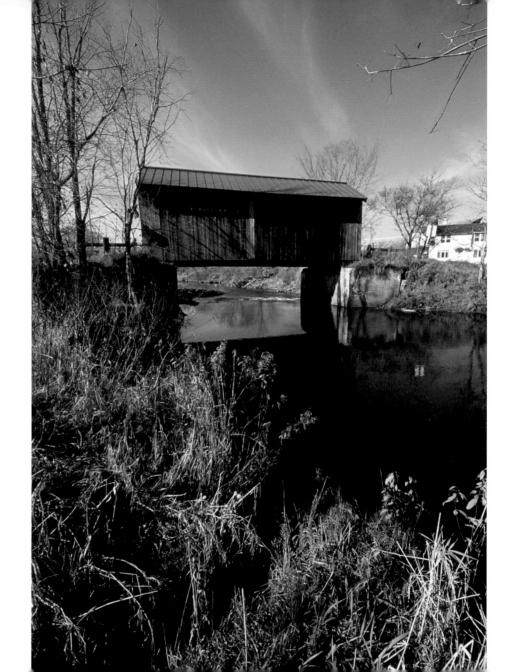

SCRIBNER BRIDGE
East Johnson,
Vermont.

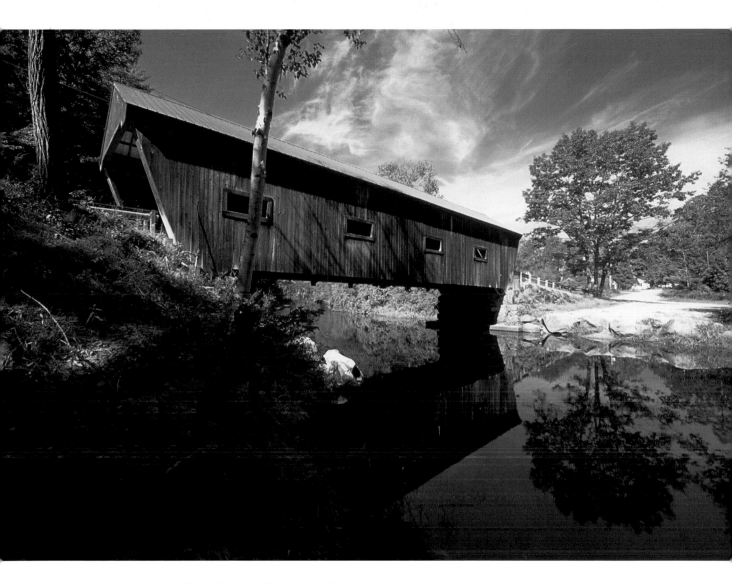

DALTON JOPPA ROAD BRIDGE

Warner, New Hampshire.

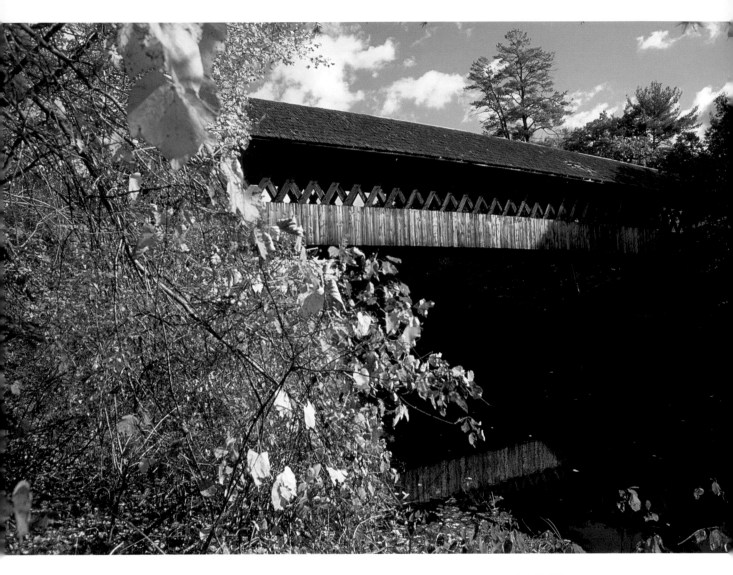

HENNIKER BRIDGE
Henniker, New Hampshire.

CHEDDAR BRIDGE
Grafton, Vermont.

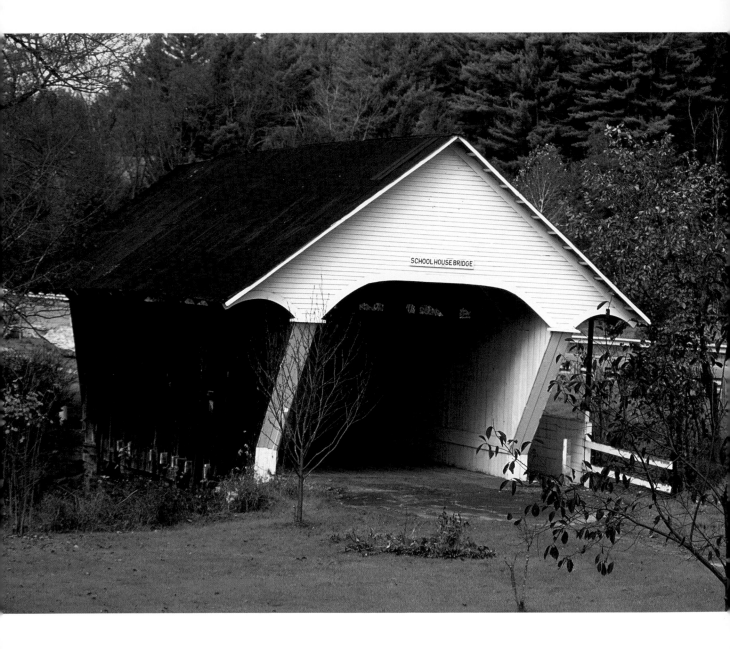

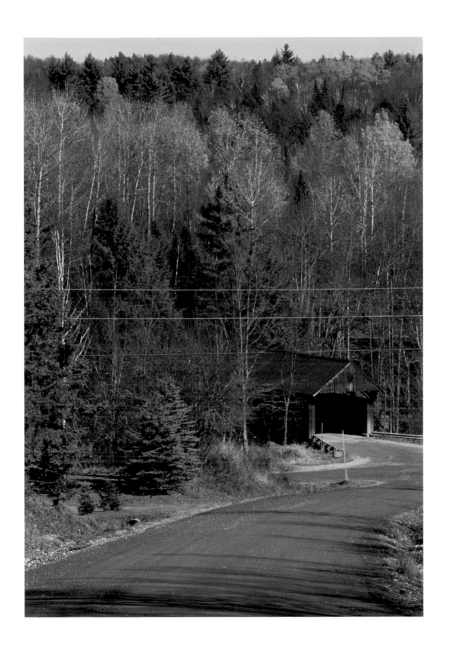

LEFT
**RED STERLING/
STERLING BROOK,
CHAFFEE BRIDGE**
Stowe, Vermont.

———

OPPOSITE
**THE SCHOOLHOUSE
BRIDGE**
Lyndon, Vermont.

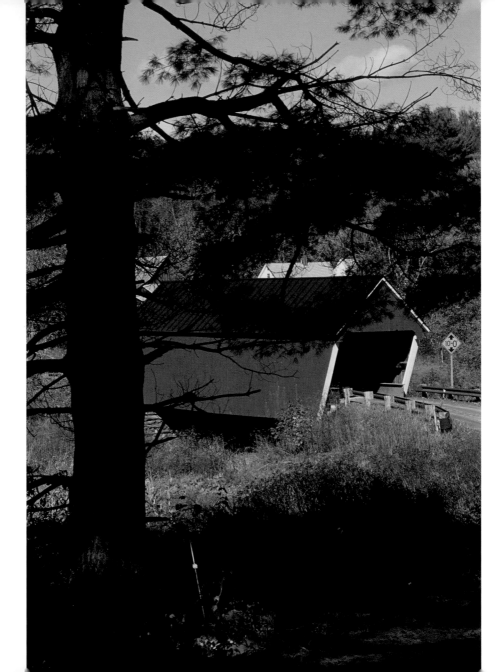

**GIFFORD/
C. K. SMITH
BRIDGE**
East Randolph,
Vermont.

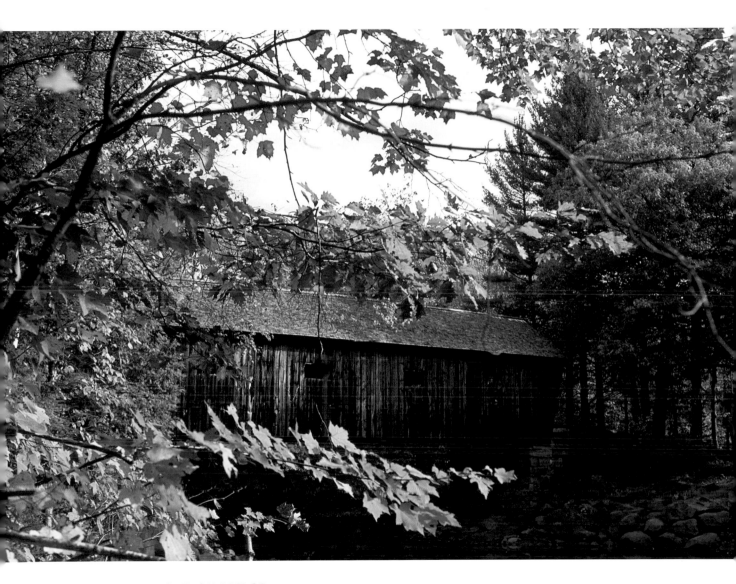

LOVEJOY BRIDGE
Andover, Maine.

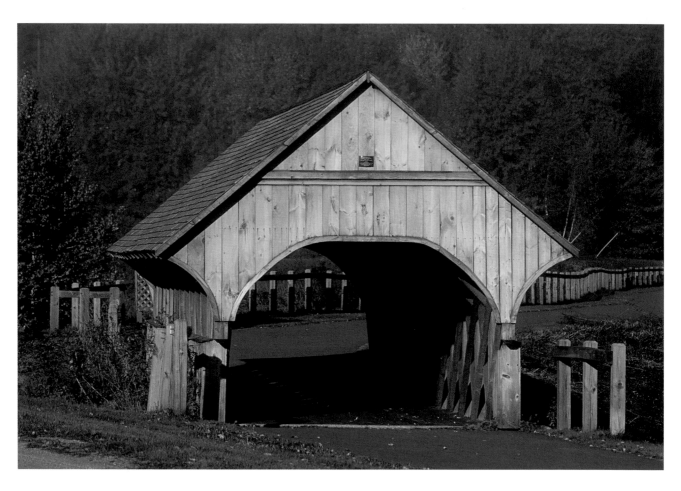

BETHEL WALKING PATH BRIDGE
Bethel, Maine.

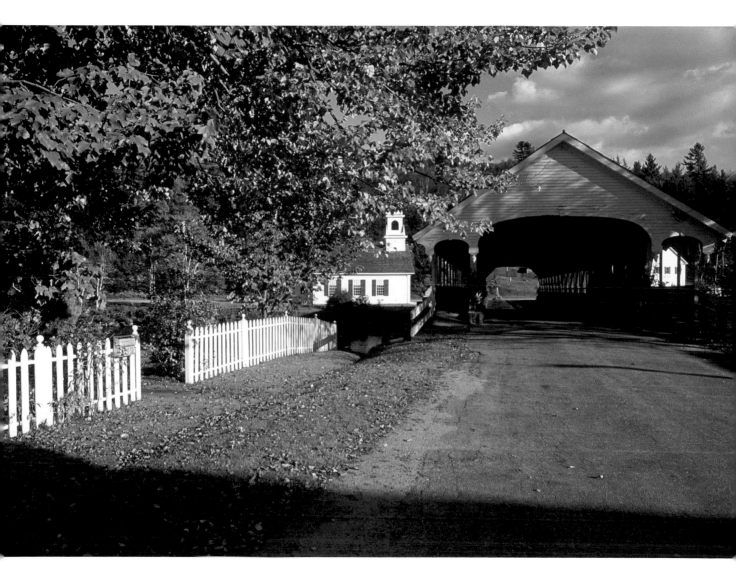

STARK BRIDGE
Stark, New Hampshire.

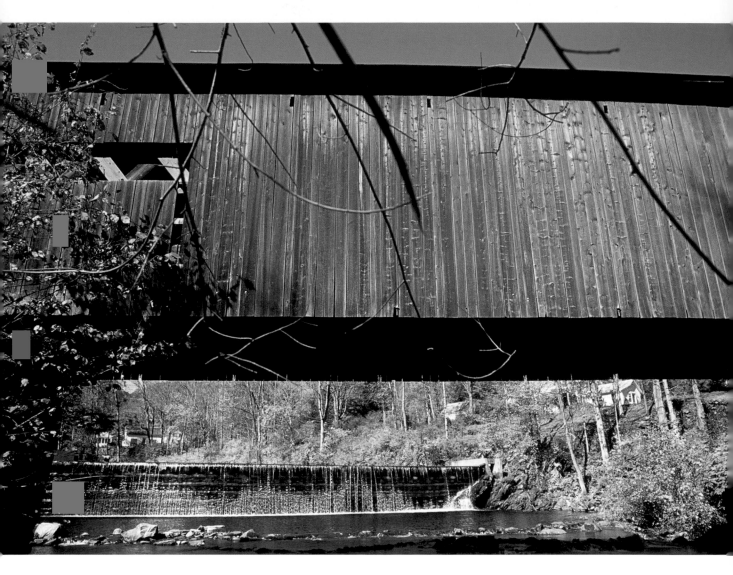

GREEN RIVER BRIDGE
West Brattleboro, Vermont.

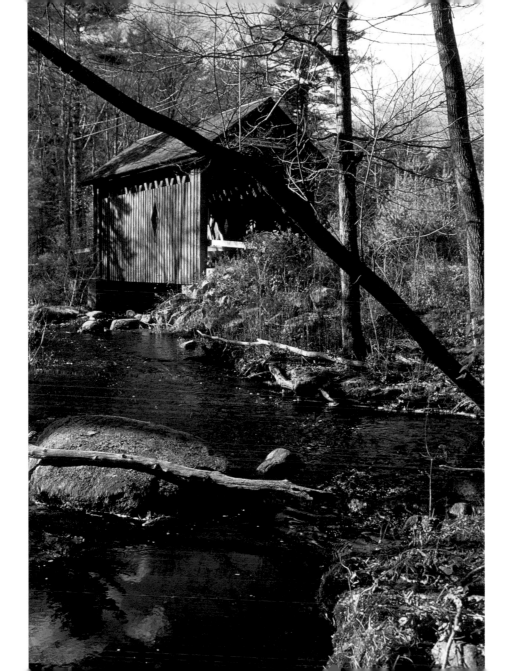

SWAMP
MEADOW
BRIDGE
Foster Center,
Rhode Island.

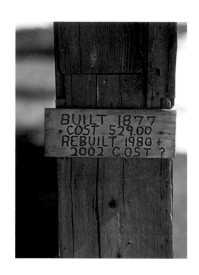

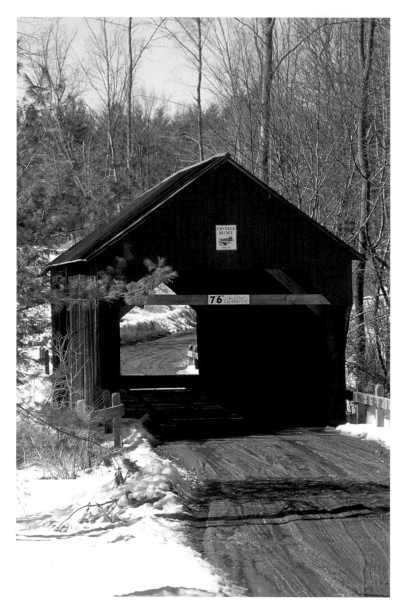

**BLOW-ME-DOWN
BAYLISS BRIDGE #23**
Plainfield,
New Hampshire.

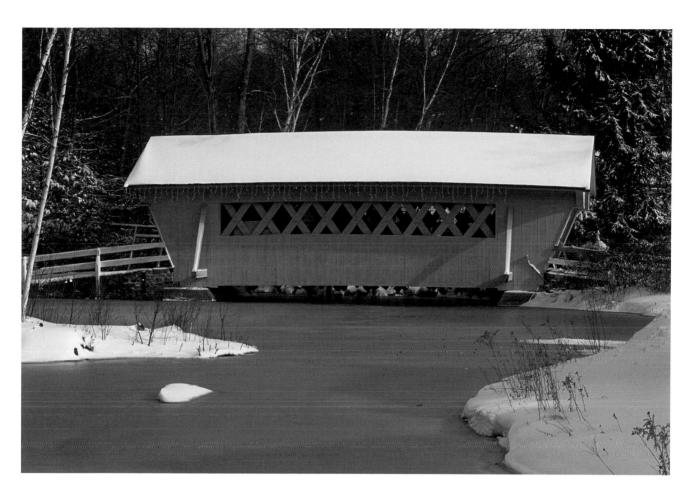

SAWYER POND BRIDGE
Magnolia, Massachusetts.

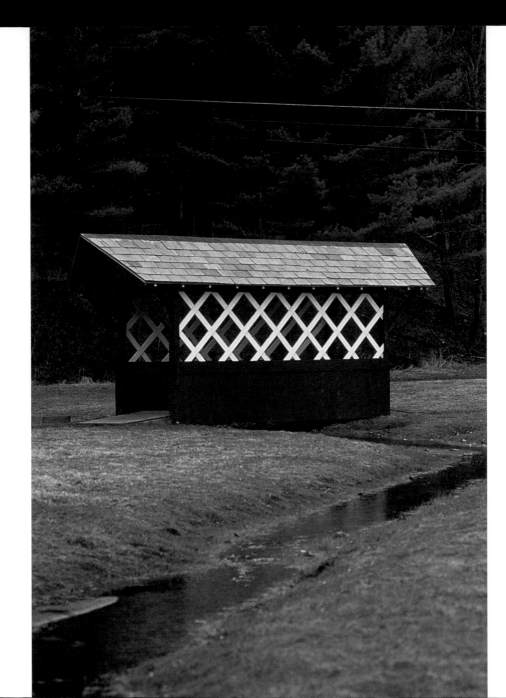

**NAME
UNKNOWN**
Townshend,
Vermont.